A LOAD BEARING ANIMAL

TINY BITS OF NOISE AS INFORMATION,
A FIELD OF FORCE, SUBTLE LIKE
SECRETS KIDS CAN'T KEEP, OR
KEPT CURRENT, LIKE A SEA DIARY

GASLIGHTS (9)
(DEATHS GET FAKED)
AN AMOUNT OF VENOM.
TRACES (6)

NOISE
HUM
LISTE
EVERY
SUR

MW00785398

# SPROUTS

SMOKE
SCREEN

THE EARTH

THE

TATOR
DING, BUT NOT TAKE PART

ROOT

A CORRECTED DOSAGE. (THAT OLD
BOOK SMELL) A CORRECT DISTANCE
(THINNER TYPE OF AIR UP THERE)

SOME SORT OF ODD
ALPHABET

RUNNING
BUDDIES

REMEMBER

(KEPT UNDER HAT
PROJECTED IMAG
A GHOST USED
SCARE OFF INTR

PS
HER TERRITORY

HER SKINS
T NIGHT
ER SEA.

ELL

BLK
LTBL
TAN
LTBL
TAN
TAN
BLACK

A SENSE OF CALM WASHED
OVER THE PACK AS THE
LARGEST TOOK COMMAND.

(A LOOK OF FEAR)

A FINALE PACK
WIDE OPEN
(DAYS WITHOUT SPEAKING)

MAGIC
GRAINS

(HERBS

LET'S DWELL ON THIS A MINUTE
nape of necks

(ALSO, EVERY PHONE CALL,
EVERY PIECE OF MAIL.)

# LVRKER

1) THESE MARKS ARE
OBVIOUSLY THE TRACKS
OF INSECTS DO!
PROOF OF THIER PRESENCE
DISTURB YOU?

2) NO THEY ARE SIMPLY ANOTHER
ELEMENT WE MUST
NOW CONSIDER.

NOW REMEMBER: THIS IS
A DANGEROUS AND HIGHLY
CAPABLE ANIMAL WHO
THINKS QUICKLY UPON ITS FEET

OH, IT'S ON!

CELLS, FLEAS, MOTES, MITES,
WRECKS
ANIMALS WHICH LIVE SICKER AND DI
(TESTED ON MICE)

FIEGN DEATH
POSSESS GREAT CUNN
PRODUCE VENOM
DRINK BLOOD
DISPLAY INTELLIGENC
USE TOOLS
HUNT IN PACKS
MATE FOR LIFE
EAT PLANTS

# FRONTS

(TIME LIMITS)

PLUS, THE IMPORTANCE OF SURROUNDING
ONESELF WITH A VARIETY OF
SUPPORT OBJECTS/SAFE, WARM
AND INSIDE THE HOME.

OSS DISTANCE

SET TRAPS
MARK THIER TERRITORY
SHED THIER SKINS/COATS
HUNT AT NIGHT
LIVE UNDER GROUND/IN THE SEA
MIMIC THE HUMAN VOICE
LAY COUNTLESS EGGS/SINGLE EGG
STING OR BITE
GROOM ONE ANOTHER

fevers
fevers ssnakesss

1) IT STAYS WITH
EVERY SECOND, THE
FUTILE HIGHS AND
MADDENING LOWS.

2) IT APPEARS IN DREA
EVENTS IN DAILY LI
SEEM TO REFERENC
IT BY COINCIDENCE

3) IT BEGS TO BE
DISCUSSED, AND YE
NO ONE SEEMS
MEN ON IT.

4) IT'S POWER COM
FROM IT'S ABILIT
REMAIN UNEXPLAIN

BREATH
THE STORE OR DOCTOR!
THE LOW
(8)
HELL)
A HIRED GUN
SOFT FOCUS    WHEN HEAVY WENT HEAVY.
(PUSHES OVER EDGES)
FGRADE
SAFE AND INSIDE THE HOME
TEMPER, TEMPER
A SENSE OF CALM

BLOWS!

A STONE MARKING THE LOCATION OF A GRAV.
A FIGURE ON A MAP
TRACKS OF AN ANIMAL
VOIDS (5)
KNUCKLE HEADS
DETES FORWARD
2) SENSE OF SMELL REDUCED

EGGS

SUBTLE, LIKE A PREGNANT PAUSE.
AND ALSO THE AMOUNT OF HEAT

SYSTEM
HACKS

# babel

Gingko Press in association with R77

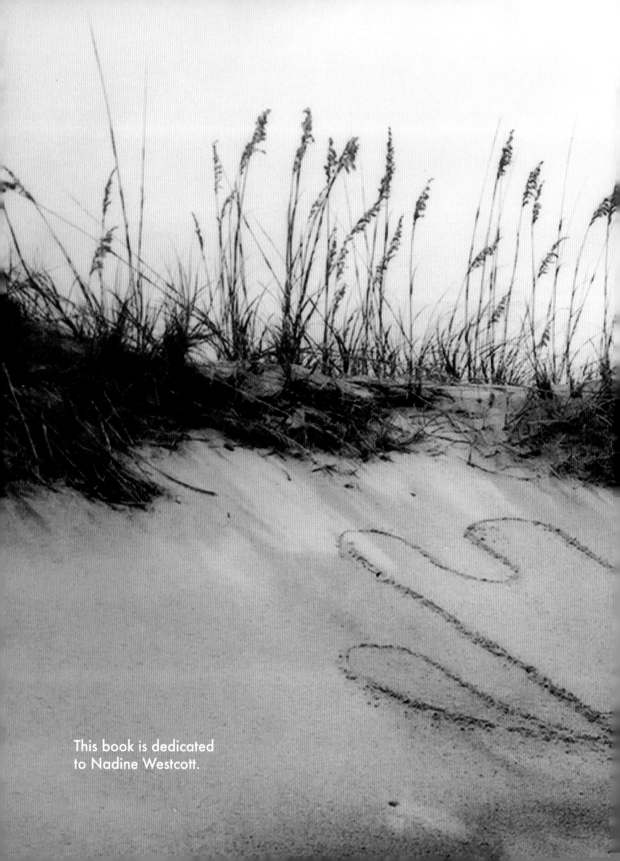

This book is dedicated
to Nadine Westcott.

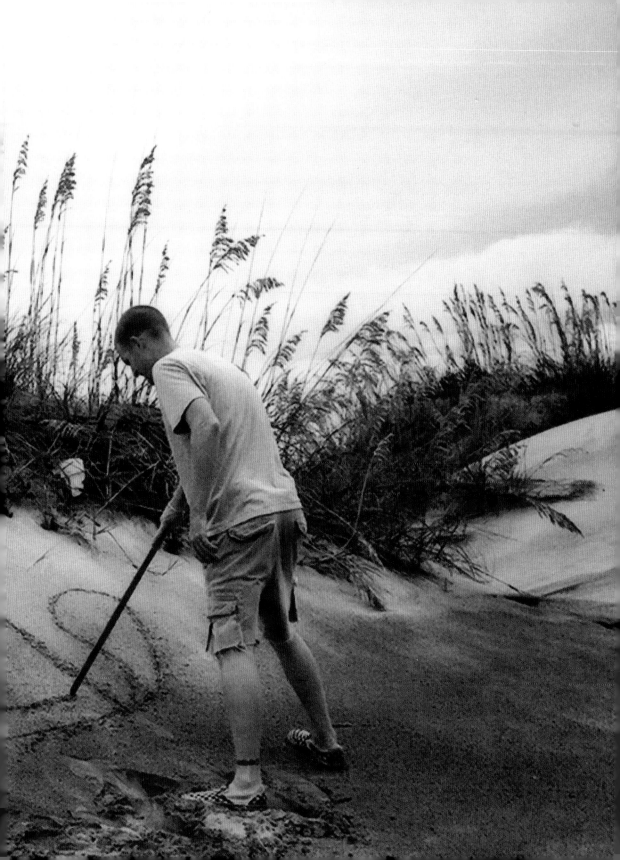

Published in 2005 by Gingko Press and R77
All Artwork copyright © 2005 Jim Houser, All Rights Reserved

ISBN 1-58423-198-X

Compiled and Edited by Roger Gastman and Jim Houser
Art Direction by Tony Smyrski (www.crashcontentcreative.com) and Jim Houser
Foreword written by Shelley Spector
Interview by Mary Chen
Photography by Adam Wallacavage, Dan Murphy, Rebecca Westcott,
Ben Woodward, Micaela Walker, Don Houser, and Shelley Spector.

Gingko Press Inc.
5768 Paradise Drive, Suite J
Corte Madera, CA 94925
USA

Telephone: 415.924.9615
Telefax: 415.924.9608

books@gingkopress.com
www.gingkopress.com

R77 Publishing
PO Box 34843
Bethesda, MD 20827
USA

info@graffsupply.com

Printed in Hong Kong

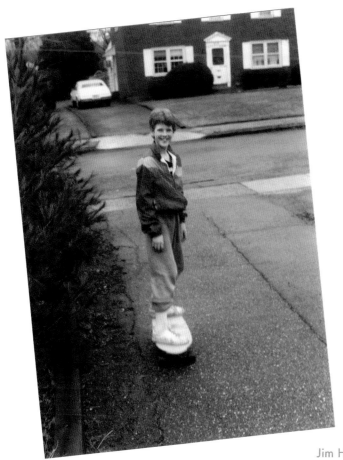

Jim Houser, 1985

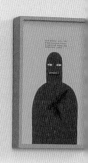
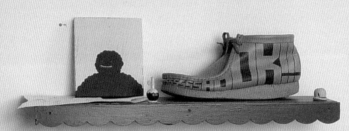

✳ AN Ø OF THE YEAR AWARD

✳ PARTICLES

THIS STAYS
WITH YOU,
EVERY SIMPLE
SECOND,
QUIET AND
QUICK LIKE
TOUCHES

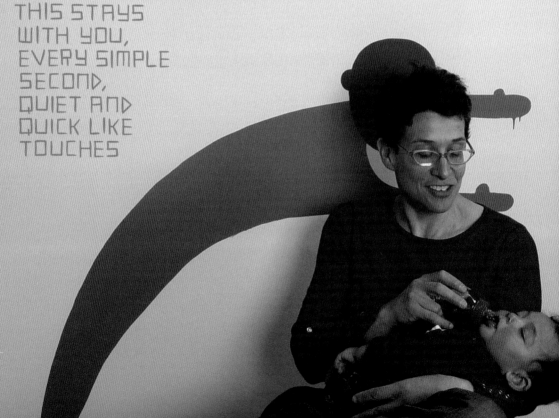

Jim Houser is a self-taught artist who paints at night while the rest of the world is sleeping.

In his work is a personal iconography of seemingly random words and images, inspired by a love of color, words, science, plants, animals, and people. He is a wordsmith who observes the ironies of the human condition and cuts them down to a single word, phrase, or symbol. His playful canvases, loaded with meaning, often read more like short stories or poems than traditional paintings.

Houser's work is completely self-immersed without being self-indulgent: it includes much of what surrounds him without passing judgment. Blessed with sensitivity and constant inspiration, he is a prolific painter with a strong work ethic and impeccable craftsmanship.

In 1997, Jim was working at a gas station on Cape Cod, Massachusetts. He hadn't started painting yet, but in the journals he kept since childhood were some of the characters and words that would soon be part of all he painted and drew on. He had left Philadelphia to be around Rebecca (Becky) Westcott, his late wife who was then his girlfriend, while she finished art school. Being around Becky and other painters coaxed his penciled ideas out of his sketchbook. A tenacious painter from the beginning, his first goal was to do 100 paintings on old skateboard decks.

Jim and Becky swapped images, ideas, and palates. The borrowed material would render itself unrecognizable, as it made its way from one's canvas to the other's. Take the text and plants they both used: what looked like a faded antique seed package in Westcott's work would look like a colorful cartoon in Houser's. They often showed their work together, and, despite their stylistic differences, their work meshed. It complimented and dovetailed, as did their life together, a visual sounding board for ideas and constant inspiration.

After a few years of painting on skate decks, canvas, scrap wood, and other found objects, Houser decided he needed to create a complete environment. To prepare for his second solo show at my space in Philly during 2000, he used photos of his first show to sketch out his idea. Where the walls had been plain white, he drew large colorful characters and text. He wanted to paint directly on the walls and hang paintings on top. With free rein to paint on anything but the floor, he created the first incarnation of his signature installation style.

His installations have grown to include hook rugs, painted shoes, basketballs, beads, fake potted plants, sketches on paper, and painted sculptures made from wood, clay, and cast stone. The installations often are accompanied by a 'zine, which can usually be used as a sourcebook for some of his images and ideas. For one show, he made a soundtrack to his own compositions. Jim has also designed shirts, skateboards, books, furniture, posters, and sneakers for Nike.

Houser commands artistic control over all things bearing his name. From the pages of this book to the box for his sneaker design to the color of paper for his price lists in his gallery exhibits, his aesthetic vision is strong and his input crucial. Although the work comes off fun and high-spirited, it is backed by Jim's stubborn and fierce loyalty to his own ideas. He is part of a lineage of artists, ranging from James Neill Whistler to Keith Haring, whose art extends far beyond their canvases. Whistler (think Whistler's Mother) involved himself intimately in the presentation of his work. He would even go so far as to have gallery attendants dress in colors that complemented his paintings. Haring reproduced his work commercially and placed his iconic images on a large collection of products, affording him the opportunity to control his own market and remain independent.

For the first few years Jim lived, painted, and showed his work in Philadelphia, people called him "the skateboard artist." To call him that now would seem belittling. His work lives as comfortably in skate parks and on the streets as it does in galleries, museums, law firms, children's hospitals, and numerous public and private collections.

Jim Houser's paintings are generous maps of interlocking ideas dumped from a mind that is constantly moving and free-associating. The following pages hold not only his raw materials and inspirations but also the work itself. Here are all things Jim: his life, his work, and his community.

Shelley Spector 2005

# LITTLE JIM

**I want to know if you drew as a little kid.**
Yeah, I drew all through grade school. My dad's actually the reason I kept sketchbooks, because I used to just draw on loose-leaf or pieces of typing paper, and he was like, "You should have all this stuff in one place so you can look back on things that you've drawn." Even when I was young, like 7 or 8, I had a sketchbook. I paint more now, but I still keep a sketchbook.

**When did you start writing in them?**
Probably not until high school – the angsty years. Before that, it was all drawings and maybe some comics.

**When did you start skateboarding?**
Around when I was 11, during the early '80s skateboard boom, when everybody started skateboarding. Then pretty much all the kids in my neighborhood stopped, so I skateboarded by myself. In high school, I met other skateboarders.

The first person that I knew I looked up to art-wise—but it was more for skateboarding—was Adam [Wallacavage], 'cause he was the older kid in our neighborhood that was super good at skating. And at first I admired him for that, but then I realized he shot photographs and did 'zines and stuff, so I started doing it too, letting people know that I liked to make art.

**What kind of stuff would you write about?**
It moved from, "Dear book, this is what I'm pissed off about today," to where eventually I was just writing about writing. I became more interested in the thing itself than the ideas I was putting down. That was when the writing moved towards just poems and stuff and obsessing with order. All those things [ended up] pared down to elements on my paintings.

**Did you major in writing that time you were in college for five minutes?**
I didn't have a major. I was going for free because my dad works there, and since it didn't matter to me to be able to go, I took it for granted. It was just like, "Oh this class on Hitler seems interesting; this class on the planet seems interesting." I was going to college like watching television, just changing the channels every three months. But none of the classes I was taking had anything to do with me becoming a worker of some sort.

# UP TO PROVIDENCE

**How did you end up in Providence?**
Around Christmas of '95, I was just so sick and depressed. At the time, Ben [Woodward] was in Providence [attending RISD] and needed a roommate, missed hanging out with me, and had a job I could do if I wanted to move. He was like, "You just need a change."

I left like March or April of that year. I had no money at all. I think I went up there with $200, which, at the time, I thought was a lot of money. "This'll last me a year! What am I gonna spend 200 bucks on?"

**So, with everyone you knew up there going to RISD, did you go intending to work on art?**
No. Seriously, if Ben went to University of Chicago, I would have ended up in Chicago. It had nothing to do with the art school at all. It just worked out. You're in Providence, which is a really creative town, you're living with someone who goes to art school, you're going to meet all of his friends 'cause none of yours are there. And then you meet the right people and the right people inspire you.

**You got to use the RISD facilities, right?**
Eventually after living there for a little bit and making some friends, if I needed to use a computer I could go here, or if I needed some paper I could go there. And there was a huge woodshop and they had trashcans and trashcans full of scrap wood. And I met a friend who was like, "I seriously don't think anyone would care if you took all this wood." So, when I first started painting, all the stuff I painted on was wood from that woodshop, my skateboards, and my friends' skateboards: just pieces of wood that I found.

**How did you go from drawing to painting?**
Ben and I were living together over the summer in this middle-of-nowhere town in Cape Cod, with nothing to do. We were living on the cape 'cause Becky was on Nantucket. I had just met her, and Ben was like, "Come up here. We'll get jobs, we'll work for my dad, and on the weekends you can go over and hang out with Becky." That was why I was up there. We were working ten-hour days, and we would come home and sit on the couch and draw. We found these watercolors one night, and I would draw a guy in pencil and fill it in with color and it was like, "Hey, remember how to do this from high school?" That summer we were like, "This is fun! We'll watch the Olympics and paint! In the middle of the woods!"

I had been over to Nantucket to visit a couple times. I met Becky's mom for the first time; her mom's an artist and she does children's books. I was talking about art with her mom, and she saw my sketchbooks and stuff. She was like, "It's so funny, everything up to page 37 is in black-and-white and then, all of a sudden: colors!" Her mom was the first one that bought me a set of real paint. For my birthday, she got me a really nice set of acrylics, some good brushes, and a little wheel to mix colors in, which I had forever. It was the best. And then I went back to the cape, and it was like, "Yo, I got real paint! Don't use it all up, 'cause I don't know what it cost!"

By the time I went back to Providence, I was full-on painting. And I was like, "Wow, my mind is quiet when I do this. It's all going some place else. This is all I want to do." When I got back, I was painting as much as I worked. If I had a job where I worked seven hours a day, I painted seven hours a day. I painted and painted and painted and just gave away everything, 'cause I was still shocked that I could do it. I wasn't trying to do anything with it. It was like, "Wow, this is rad. I drew it and not only did they see it, they saw it and wanted to keep it." I really liked doing that. I really liked having as much stuff as I could out in the world, and if someone would see something and like it, I'd be like, "Here, have it!" And it seemed to mean a lot to them to do that, but to me it was just like, "There's this much less room in my room, 'cause there's this thing in there that's already had stuff done to it – on both sides."

**How do you think things would have been different, or would they have been, if you'd gone to art school?**
I think that a huge part of it is finding my own way. I've always been the kind of person who needs to figure things out for himself. I didn't take advice very well, didn't take criticism very well, and didn't take direction very well. I think the thing I may have missed out on was learning different kinds of art, but I don't think it would have helped my painting. Maybe I'm being shortsighted by saying that, but early on, I met people that were older than me that had gone to art school, and when they saw my paintings were like, "Wow, you never would have done this if you went to art school. This would have been beaten out of you." To me, art school is not important, but being friends with people who went to art school is.

**Just curious – how come you never went through a graffiti phase?**
We got into it for a summer, a while ago. Back before Ben and I first started painting. We never got into writing our names, but I was drawing a turtle, which is like the opposite of graffiti. I would draw this turtle really carefully in spray paint, and it would take like a half an hour to do one, so it's really retarded that I never got arrested. Ben and Andrew were drawing eggs and a glass of milk. That was their tag: eggs and milk. We just did that for the whole summer. The breaking the law part of it, being young and stupid, was definitely fun. But you really have to be into that next level-type thing where you just want to get your name out and have a rep and know about graffiti, and we weren't into it.

## BACK TO PHILLY

**When did you move back to Philly?**
After that was the year when everybody from Providence from Ben's year graduated and moved back to Philly to start a gallery. And that was my first big show, at Space 1026. I was still in Providence when the Space was started, and I think Ben was, too, but they had already figured out that they were going to have a gallery and what was going to be in it month by month, and he

was like, "This is when your thing's going to be. Be done by then. You need to fill up this gallery by yourself." And I was like, "I'm gonna need like a hundred paintings!" And that was the name of the show: 100 Paintings.

I had the idea in my head that when we moved back to Philadelphia, we would get a house set up, and then I was going to start working on my art show.

How was that show?
It was crazy. The space was still really new, and nothing like that had been around there in a while. People were going to come anyway, and then we made posters and just advertised the shit out of it all over the streets.

All these people showed up, and I think it was one of the first shows where people were like, "How do I buy this?" as opposed to just coming in and looking at it and leaving. And no one at the Space had a contingency plan for how to accept money. There were no receipts. There was a skateboard ramp there, and people were running up the ramp and giving me fistfuls of money. Andrew would come running up: "You sold five more paintings!" And I'd be like, "Uh, make sure they give you their name and which one they want!"

We had no clue what we were doing. I walked out that night with like $3000 in cash, just like, "This is awesome. I just made $3000 in an hour!" when it was actually like a year's worth of work. "I'll just do one of these a night and I'll be a millionaire!"

The 100th painting in that show was the ramp, right?
Yeah. We had it roped off at first. I wanted people to be like, "Wow, he did this crazy thing," and then people who didn't know about skateboarding would be like, "Whoa, and now they're wrecking it!"

How did you end up working with Shelley Spector?
I did a couple small shows outside of Philadelphia. At some point, Adam was supposed to be in Shelley's first show when she opened her gallery here. He couldn't do it for some reason; I think he had just bought his house, and she was bummed. He was like, "I'm not ready, but my friend Jim, his stuff is really cool, and I think you'll like it, and he could have a show tomorrow, he's got that much art." I brought a big book of photos down, and sat with Shelley and talked about what I was trying to do and where I was trying to go with it. I think she was just feeling me out, and we sort of clicked right away. I think it was two months after that when she was like, "Alright, I want to open this gallery." It was real quick.

It was solo show to solo show?
In Philly, yeah. I might have done a couple things, like group things at the Space, the White Out show, and that show that Clare [Rojas] curated, the Bird Show, with all bird art. There were a few things in between that, but that show was the next big thing I did. I trusted Shelley a lot as someone who knew a lot more about the art world in general. She lived off of her art; I didn't. She had a gallery that she was trying to open and would show in galleries, and she knew how stuff worked. She schooled me a lot early on. I really just put a lot of faith in her as far as, "How much stuff should I put in the show? How crammed?" 'Cause my whole aesthetic is "Let's cover every square inch in art! Let's have piles of art on the floor, people can kick through piles of art! We'll give everyone who comes in a free painting!" And Shelley was like, "No, we're not doing that."

That show was a lot more scaled-back. And it went really well. She was stoked on it and she was stoked on how hard I worked. I trusted her, and that's when I started working with her. And I think maybe a year went by between that show and my next show. She became my main gallery. That's the only place in Philly that I really show anymore.

**Was that the first time you did an installation?**
No, the next show at Shelley's was the first time I really did an installation. That came about because Alex Baker had asked me to participate in the East Meets West show at the ICA, and I'd really been becoming conscious of what was going on around me with peers, and I really envied Chris (Johanson), Margaret (Kilgallen), Barry (McGee), and Ed (Templeton) for their ability. Their individual pieces of art were small, but the way they arranged stuff and used the walls to tie everything together created something big. I really wanted to try that, because I felt like all my paintings connected in a way anyway. I liked the idea of trying to create a little world where the walls kind of tied it all together.

The ICA was going to be a super big show, just square footage-wise big. There was a lot of space I needed to fill. I really wanted the opportunity to try [an installation] and see how it felt and how it looked before I did it in a museum. Shelley was like, "Yeah, go for it." I really trusted her the first time, and the second time she really trusted me. I really didn't know what I was doing. I was just playing around, the same way I would play around on a blank piece of wood, on her walls and using individual paintings the same way I would use individual elements on a painting. It was micro and macro. After that, it was on. I was like, "This is how I want my art to look."

**Did you walk in with it planned out on paper?**
No, I never plan them out. I just do 'em. It's like: go to Home Depot, buy the shittiest, cheapest paint you can, whatever colors they have, screw them up until they look like your colors, and then go from there.

I'll remember that show (East Meets West) forever, though. That's when I first got to meet Chris Johanson, and I had met Barry and Margaret the year before, too. It was really awesome being in a show with them and talking to them about art and how they were doing it. I've always looked up to all three of them, because they're farther ahead than I am. It was just rad. It was a great space to work in, there were lots of people around, I had quiet time when I needed quiet time, and we had the ability to be stupid when we needed to be stupid. They basically gave us the keys to the museum, and I lived like three blocks from there, so I was down there from like 11 in the morning until 2 or 3 at night just working.

That was Margaret's last show, and it sucked 'cause Becky and I were like, "We just met her, she's so cool," and then she was gone.

But I'll always remember that show as being a really good thing. It was the first time I felt like people older than us understood and appreciated what I was doing. 'Cause there were people that were part of whatever the real art world is, being like, "Go do your thing." And for Alex Baker to have faith that it would be good, and it was good... everybody's stuff in it just blew me away.

**Was it the act of doing installations that got you into doing more 3-D stuff?**
Definitely. That and an interest in constantly moving forward, and constantly pursuing new media, new ideas, and new ways to make things interesting, for me and for other people. 'Cause I get bored easily, and I don't ever want someone to come into a show I did and be like, "Seen it." I also got really sick of people constantly being like, "Oh, skateboards." Honestly, I'm not going to say that I'm not a "skateboarder-artist." But for real, the reason I was painting on skateboards was because I was sponsored and they were free, and all my friends skated. That's where all that wood came from. There was no metaphor behind it at all. And that's why I started painting on shoes and basketballs and chopping boards and other things, because I wanted people to realize that they're just other objects in my life that I like to see paintings on. If I had a friend who was a rock star and got lots of free guitars, I probably would have painted on guitars all along.

# WHAT'S ON YOUR PAINTINGS?

**How do you pick your words?**
Every once in a while I'll read something or think something or hear something – a word that I like the cadence or sound of, and that combines with what it means in a contrasting way. A word that sounds really beautiful but is an awful thing, or a phrase that sounds really beautiful but is bad news.

**How does a new visual symbol develop?**
I might see an image just by happenstance. While doodling, I'll draw a shape that I really like. Something'll click and it just feels like it goes with the other things. It's like making up a new letter in my own alphabet.

Pretty much all the paintings are composed of the same system of ideas, certain things I lose interest in and certain things I get more interested in. I'll write something on a painting that I feel like writing down 'cause I like the look of it, and then that reminds me of something else visual or what color to make it, and then that color might reference a certain thing I like to draw over and over.

Phrases on the paintings that are repeated, expressions or short little poems, I just hold in my heart for a while, and then get sick of them. For a couple weeks, I might be coming in thinking a lot about sports or code-breaking or animals that live in caves or anything like that. And then all of a sudden I'm not interested in that anymore; I'm interested in something else.

You know those natural history maps that they used to have in your science book? It'll be like, "This bird existed for this long, and got replaced later by this type of bird." I really do feel like the paintings stand by themselves, but at the same time, it's like I'm working on one long painting over time. Which is why I do installations, because all the paintings relate to one another.

**Does a painting tell a story, or is it a snapshot of something?**
Maybe it's a schematic of the thought relations that were going on in my head over the course of three days.

**Do all of those phrases or memorable symbols evoke specific emotions for you, or something else?**
There's an expression I really like that sums up how I think about words: "Words mean other words." That's kinda how I think about words. We communicate pretty easily, but when I say "mom" you picture your mom in your head and I picture my mom; when I say "car" you picture your car and I picture my car. But we both know what moms and cars are, so when we're trying to describe the idea of a mom or a car we have to use other words to do it. To explain this thing, you need a whole other set of words, and then a whole other set of words to explain that.

All the things on there, whether they evoke emotions for me or are just observations I made, it's kind of like I'm actively cataloging the contents of my head at all times.

# WHAT'S THE GOAL?

**What's the goal?**
There's this artist in Philly named Isaiah Zagar who does things completely covered in mosaic. I don't know how old he is, he's gotta be like 400, but he's everywhere. Everyone knows him, he's been down since forever, he never left here, and his art is everywhere. I'd love to be that in 40 years. I'm not trying to be some famous dude at all. I'd like to continue to live off of what I do, and I'd like to continue to make art that's positive and life-affirming and that Becky would have wanted me to keep doing. Of course, perspective has changed since she died, as far as what's important, and the motivations behind it might change a little bit, but I am what I do, so I'll just keep doing it.

INTERVIEWED BY
MARY CHEN IN
DECEMBER 2004

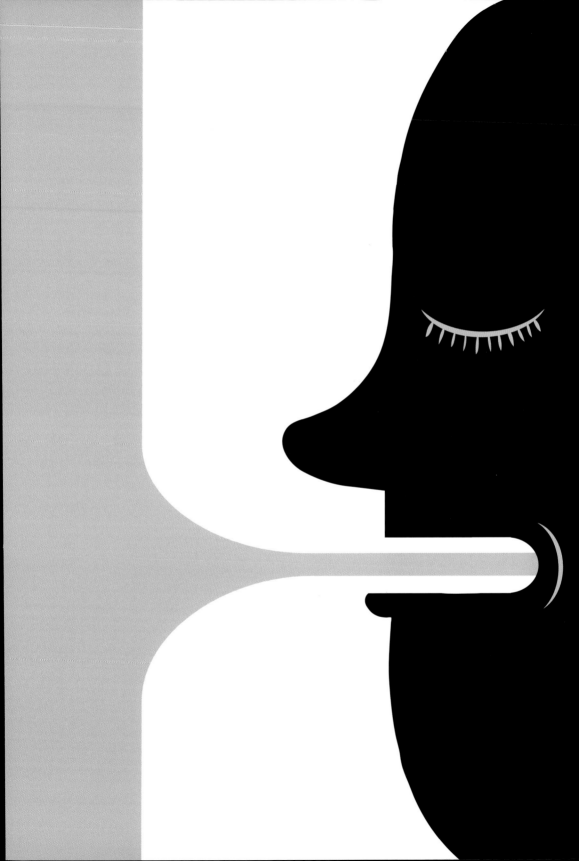

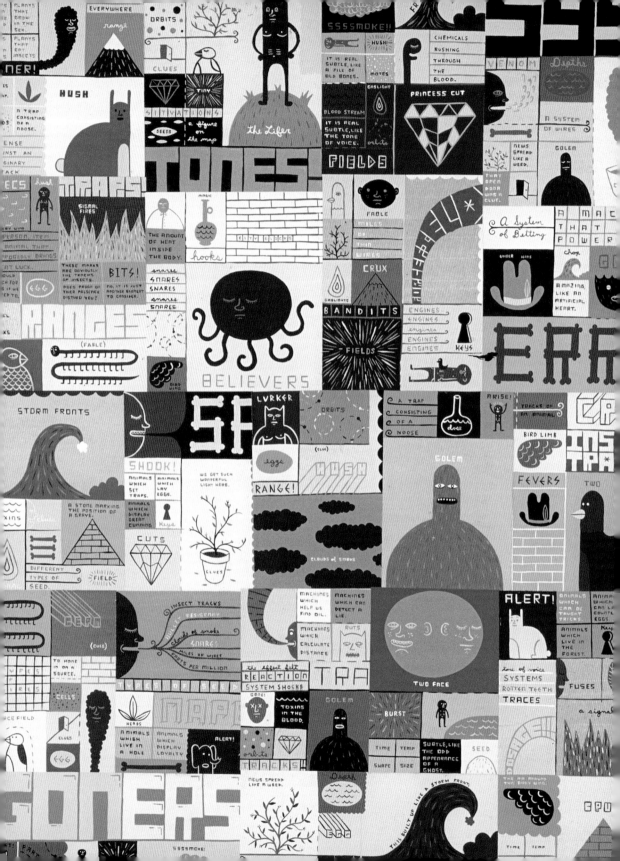

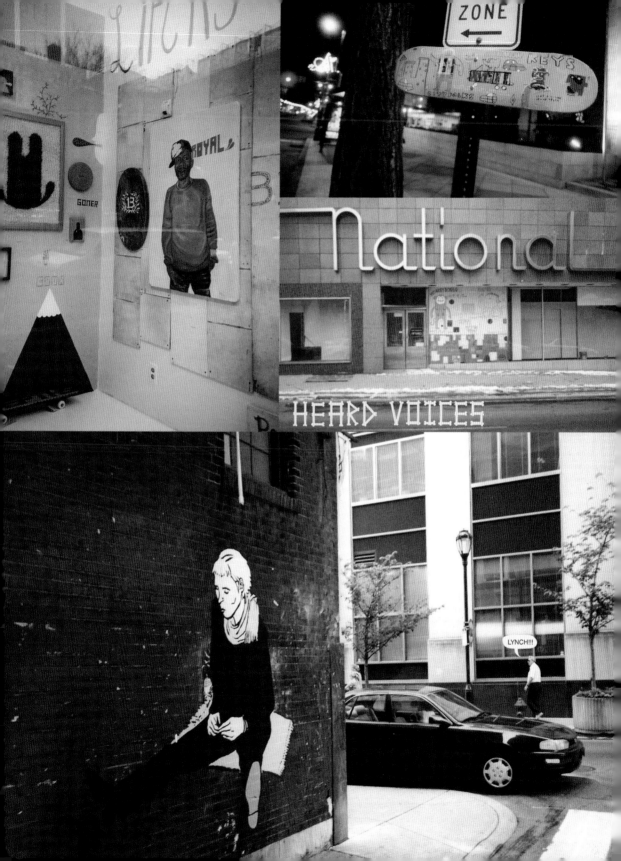

GH

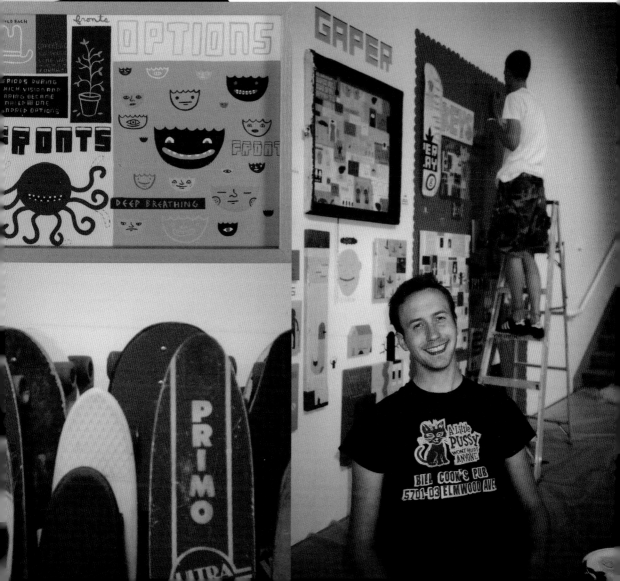

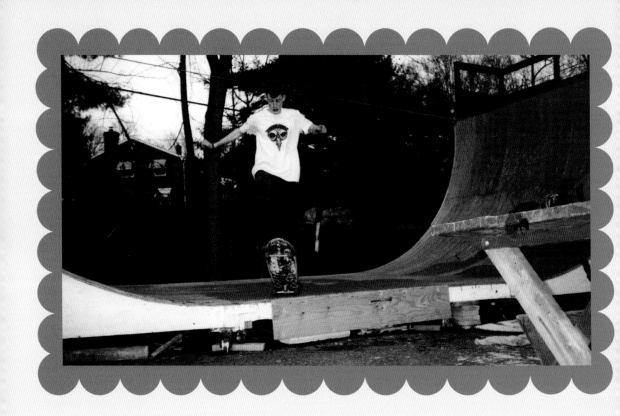

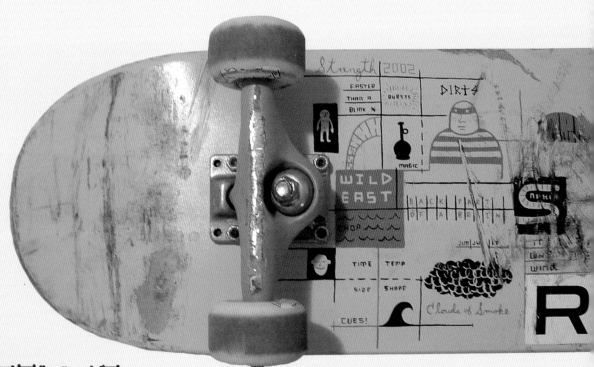

FABLES

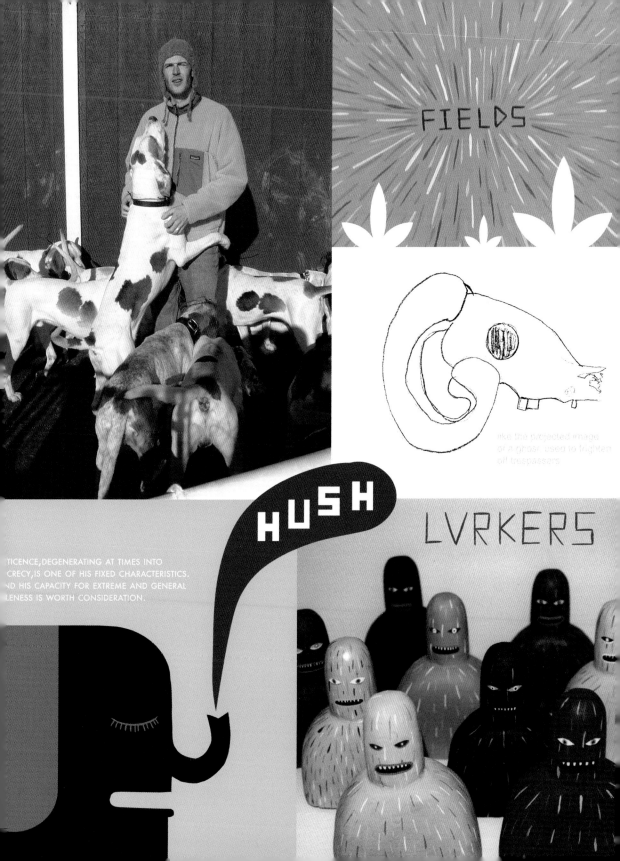

FIELDS

like the projected image
of a ghost, used to frighten
off trespassers

HUSH

LVRKERS

TICENCE, DEGENERATING AT TIMES INTO
CRECY, IS ONE OF HIS FIXED CHARACTERISTICS.
ND HIS CAPACITY FOR EXTREME AND GENERAL
LENESS IS WORTH CONSIDERATION.

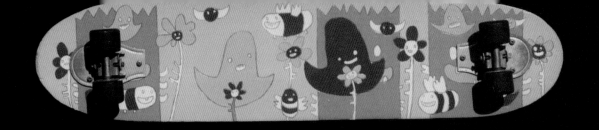

# TOXINS IN THE BLOOD

SPROUTS

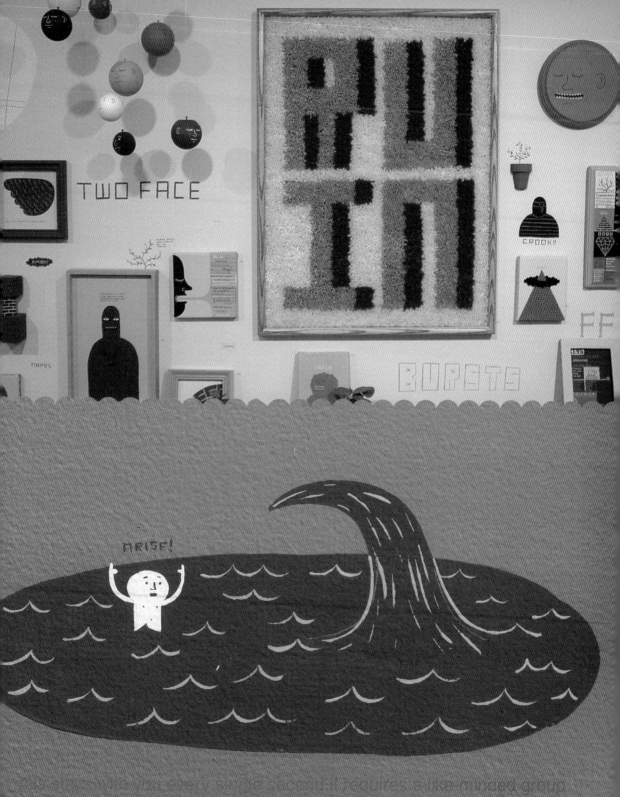

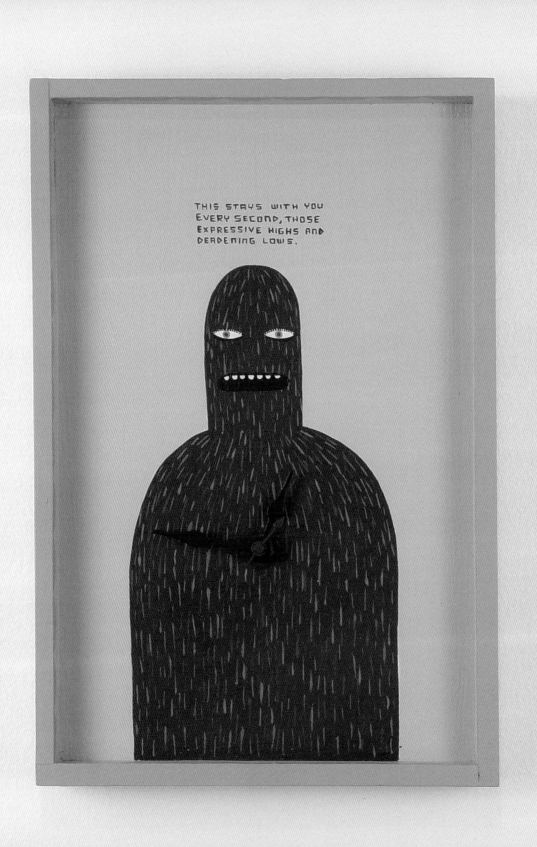

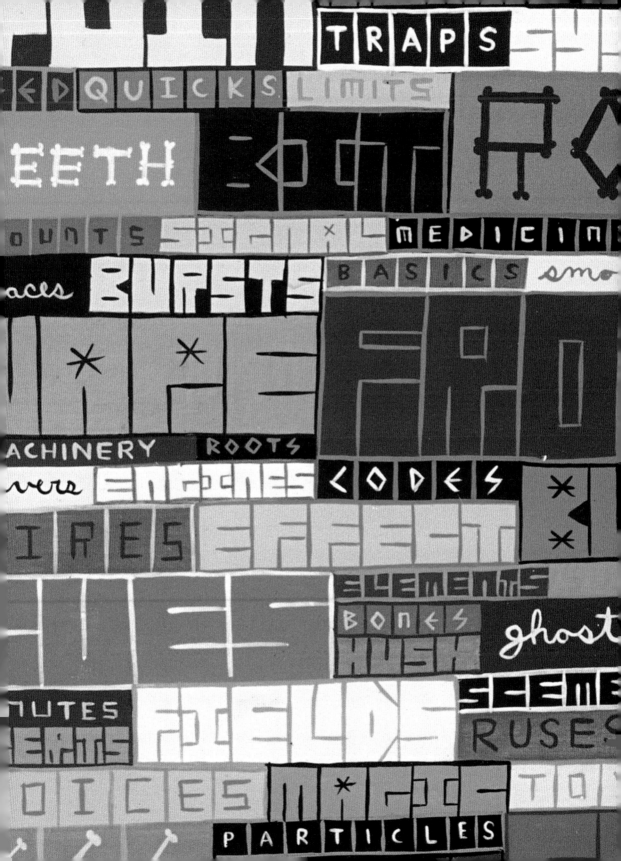

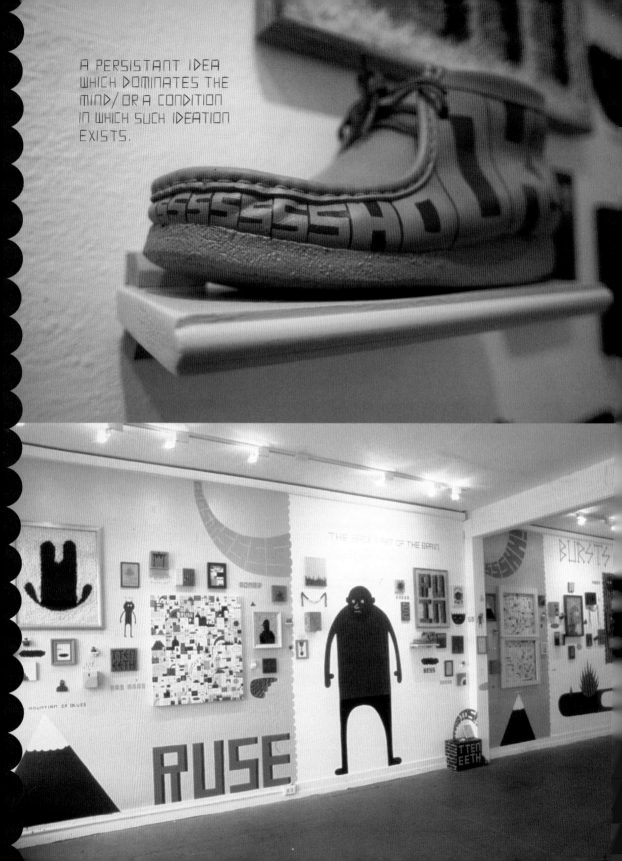

A PERSISTANT IDEA WHICH DOMINATES THE MIND/ OR A CONDITION IN WHICH SUCH IDEATION EXISTS.

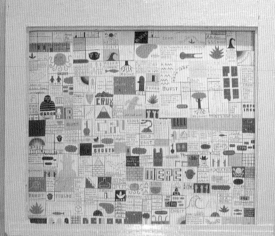

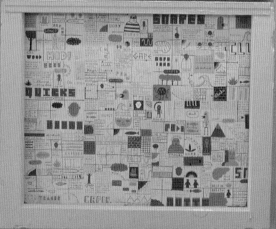

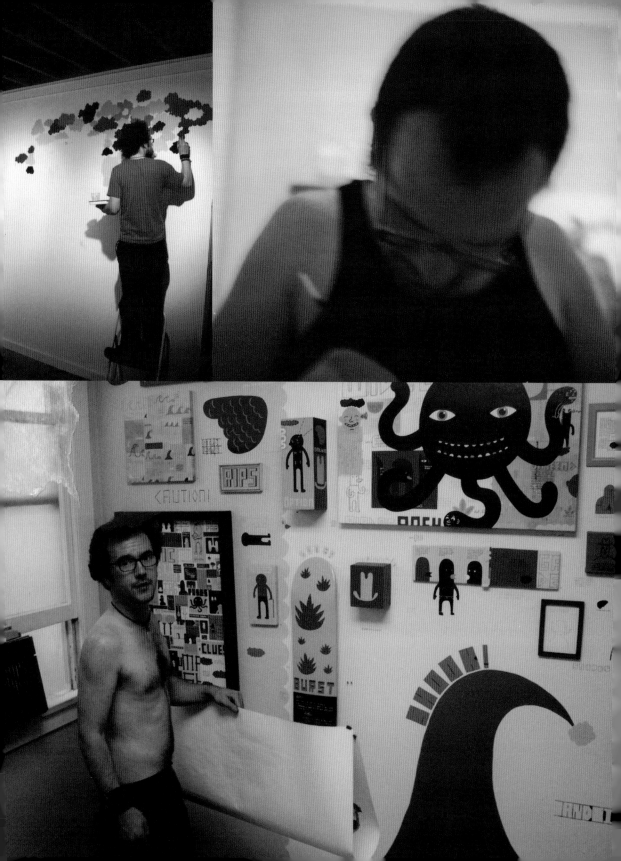

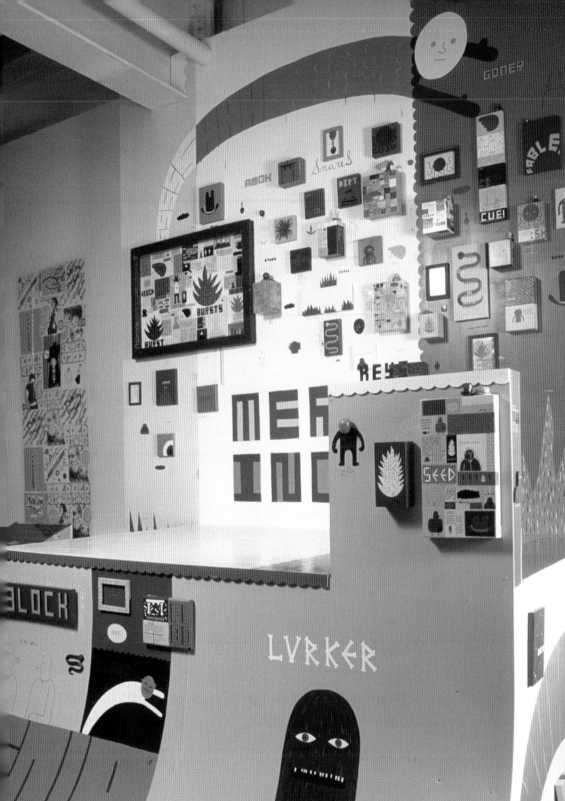

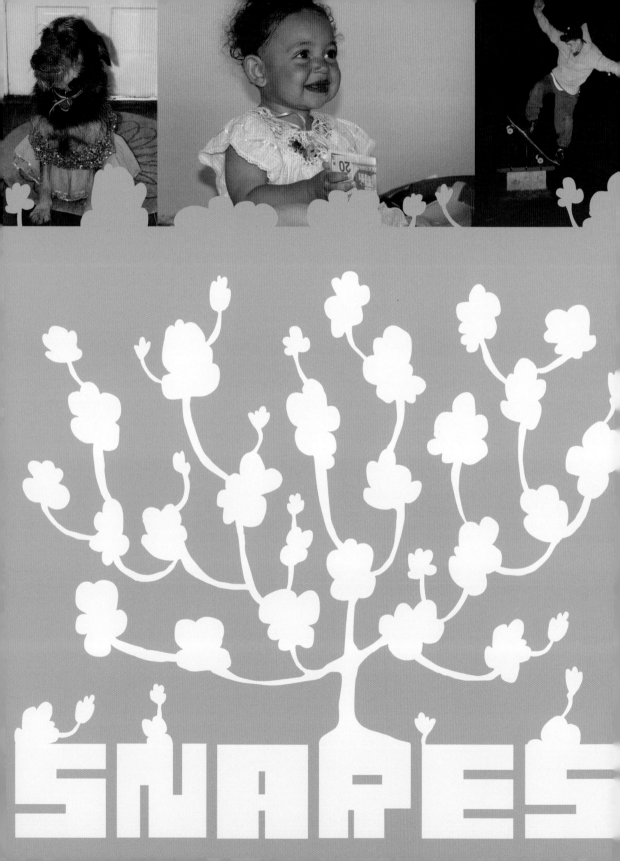

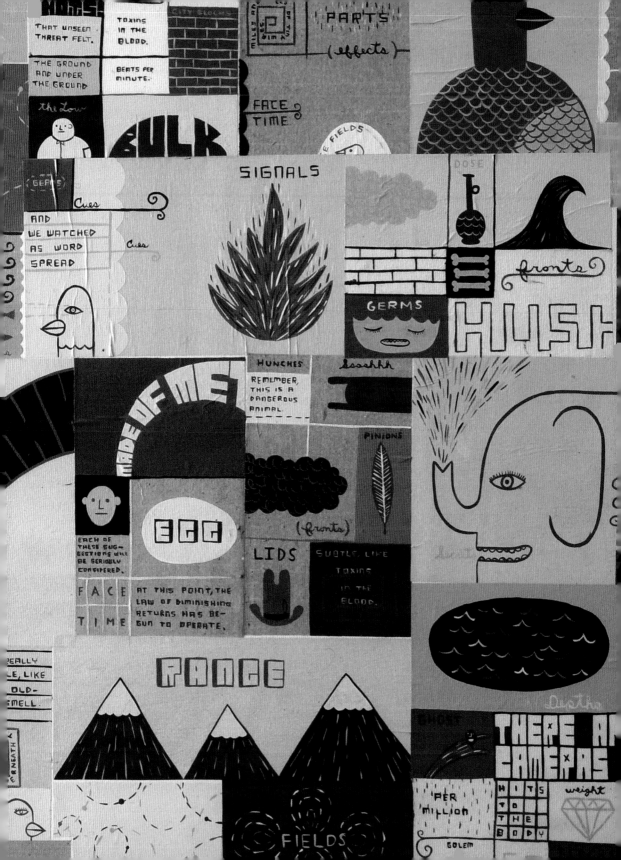

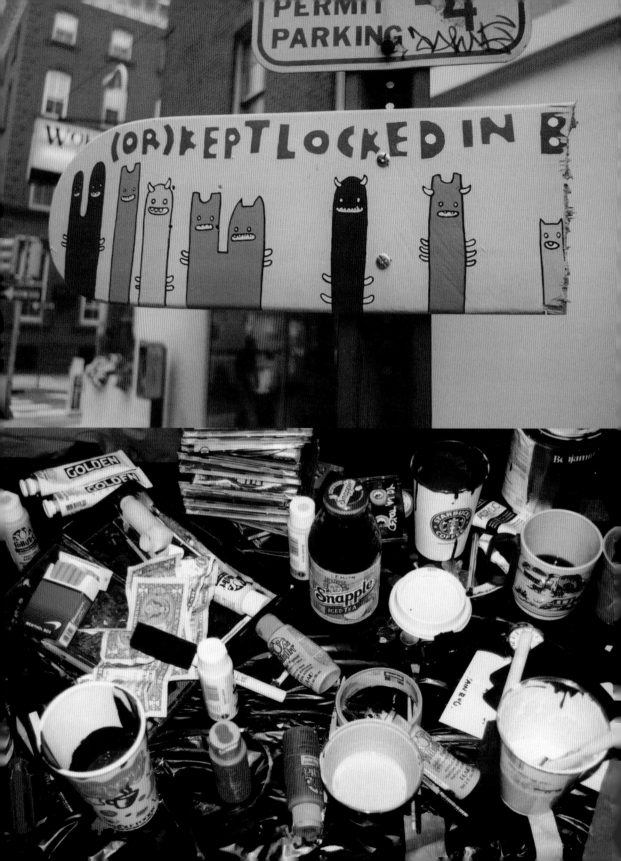

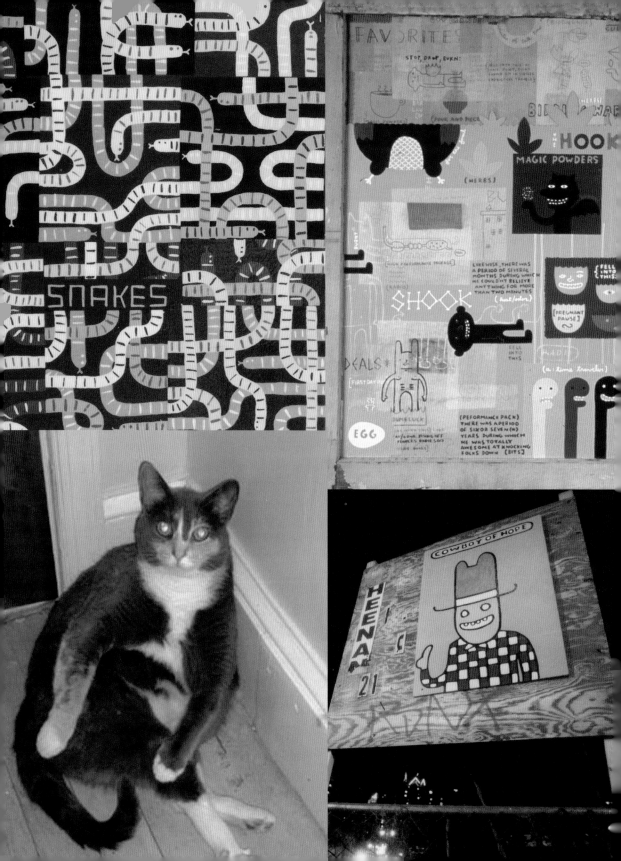

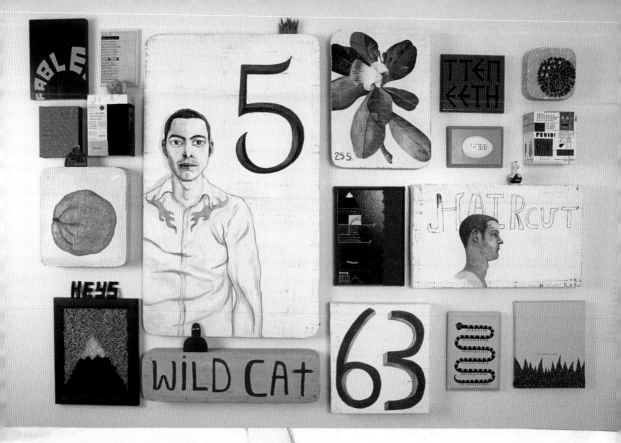

the Smell
of
OLD BOOKS

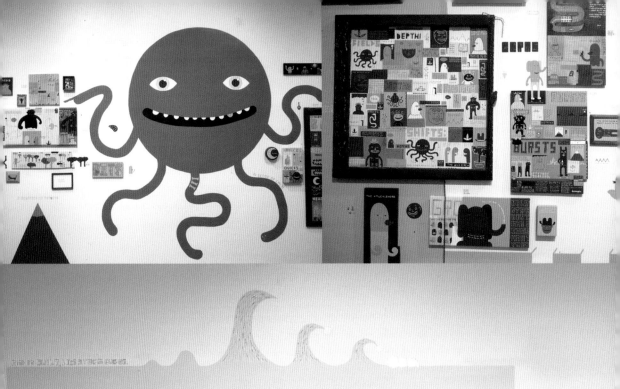
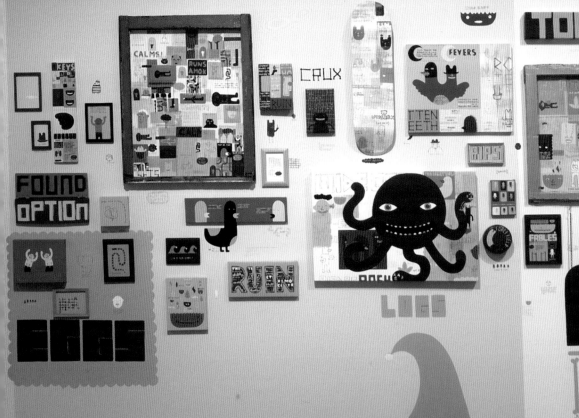

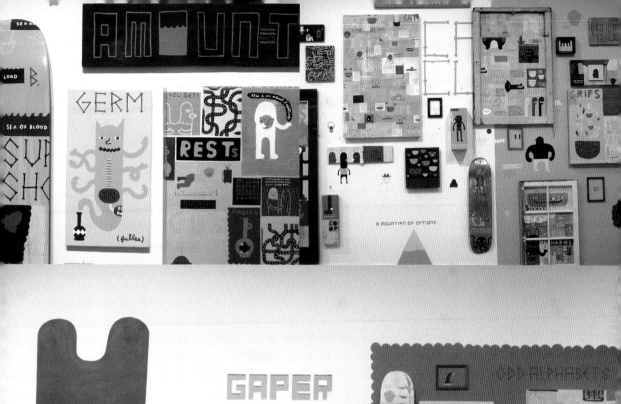

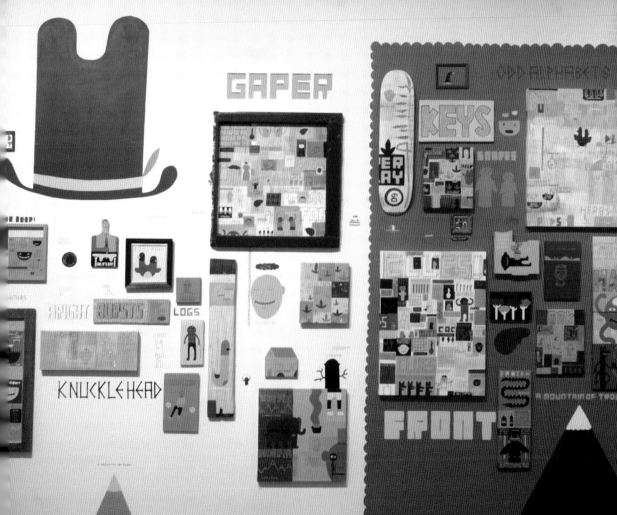

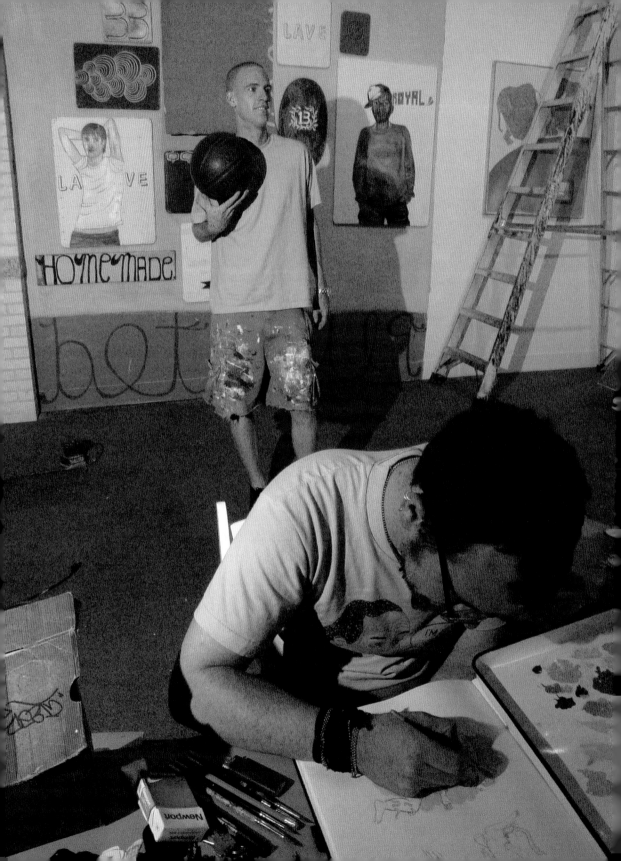

LITERATURE | STIRS | IMAGINATION

GREAT

THE

AND

IT | CHALLENGES | INTELLECT

THE

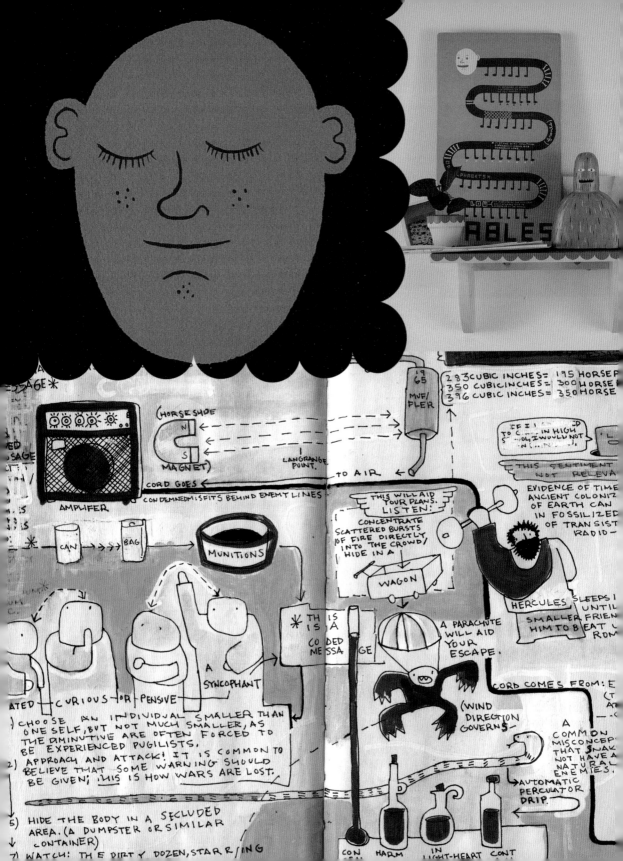

ABLES

PHREETS

LOOK

285 CUBIC INCHES = 195 HORSE
350 CUBIC INCHES = 300 HORSE
396 CUBIC INCHES = 350 HORSE

19
65
MUF/
PLER

IF I [ ]
TO C IN HIGH
S OL I WOULD NOT
N [ ]

THIS SENTIMENT
NOT RELEVA

(HORSESHOE
MAGNET)

N

S

LANGRANGE
POINT.

TO AIR

EVIDENCE OF TIME
ANCIENT COLONIZ
OF EARTH CAN
IN FOSSILIZED
OF TRANSIST
RADIO—

CORD GOES
CONDEMNED MISFITS BEHIND ENEMY LINES

AMPLIFER

THIS WILL AID
YOUR PLANS.
LISTEN:
CONCENTRATE
SCATTERED BURSTS
OF FIRE DIRECTLY
INTO THE CROWD/
HIDE IN A

WAGON

HERCULES SLEEPS
UNTIL
SMALLER FRIEN
HIM TO BEAT
ROM

CAN      BAG

MUNITIONS

* THIS
IS A
CODED
MESSA GE

A PARACHUTE
WILL AID
YOUR
ESCAPE.

CORD COMES FROM: E
T A
A

A
SYNCOPHANT

(WIND
DIRECTION
GOVERNS

A
COMMON
MISCONCEP
THAT SNA
NOT HAVE A
NATURAL
ENEMIES.

ATED  CURIOUS OR PENSIVE

) CHOOSE AN INDIVIDUAL SMALLER THAN
ONE SELF, BUT NOT MUCH SMALLER, AS
THE DIMINUTIVE ARE OFTEN FORCED TO
BE EXPERIENCED PUGILISTS.
2) APPROACH AND ATTACK! IT IS COMMON TO
BELIEVE THAT SOME WARNING SHOULD
BE GIVEN; THIS IS HOW WARS ARE LOST.

AUTOMATIC
PERCULATOR
DRIP.

5) HIDE THE BODY IN A SECLUDED
AREA. (A DUMPSTER OR SIMILAR
CONTAINER)
7) WATCH: THE DIRTY DOZEN, STARRING

CON   HARM   IN   CONT
LIGHT-HEART

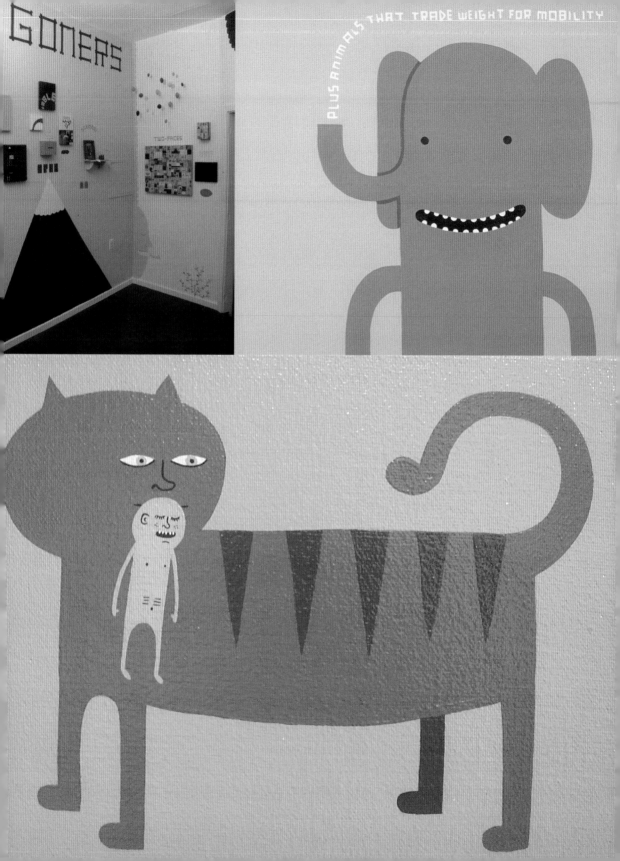

GONERS

THESE STONES ARE QUITE RARE

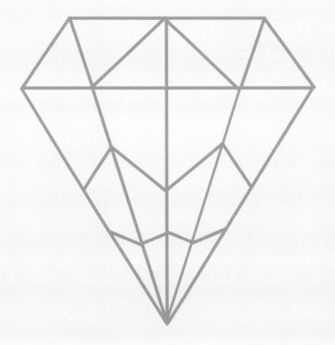

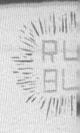
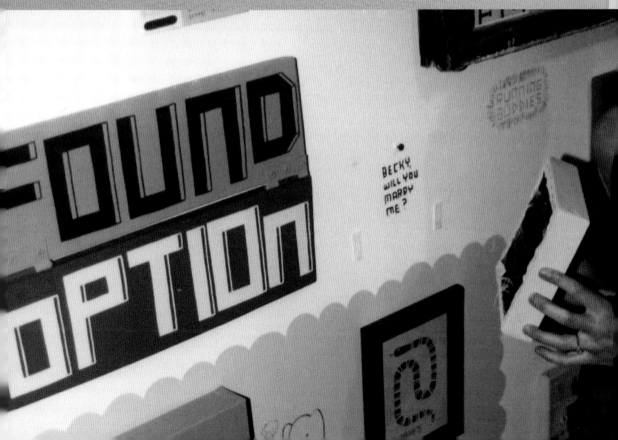

THE

DRUM

SOUND

OF

THE

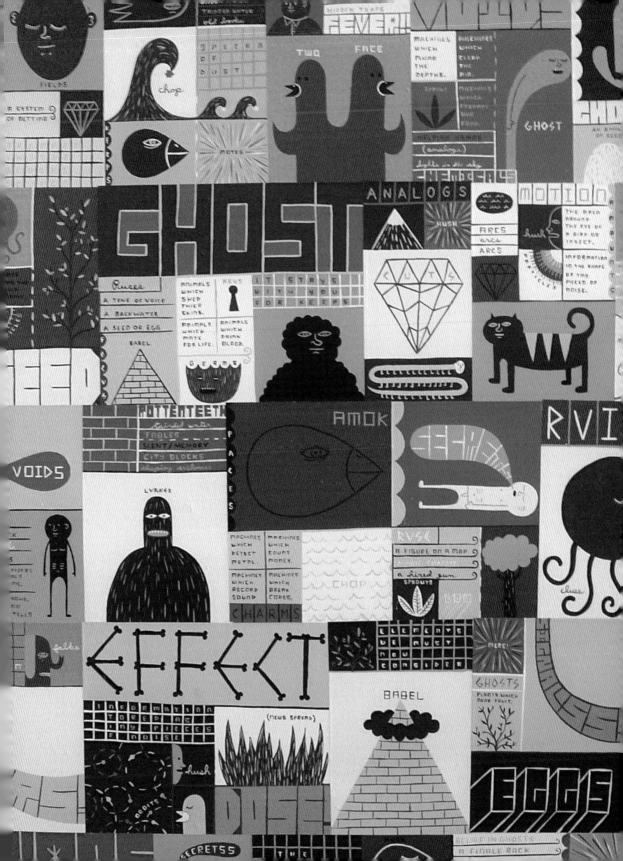

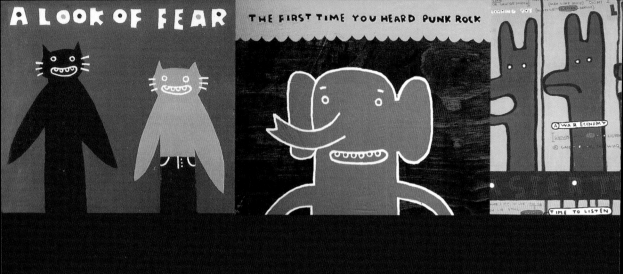

THE PRODUCT WAS
EXPENSIVE, BUT
VERY WELL MADE.

UNFORTUNATELY,
IT WAS QUITE
POPULAR WITH
THIEVES.

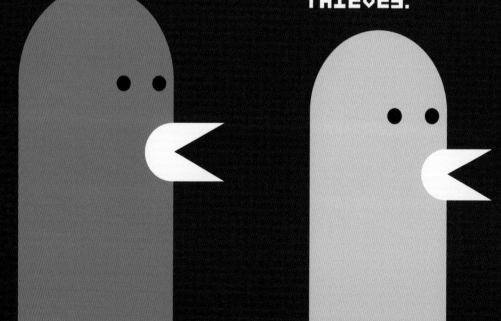

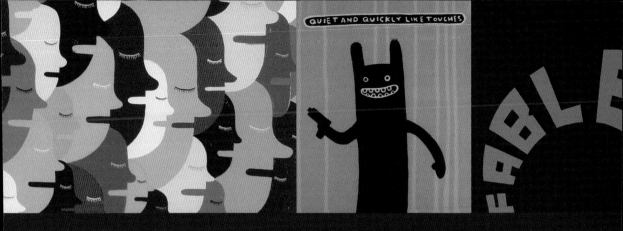

THE COMPANY FACED
HUGE LOSSES AND
WAS FORCED OUT OF
BUSINESS.

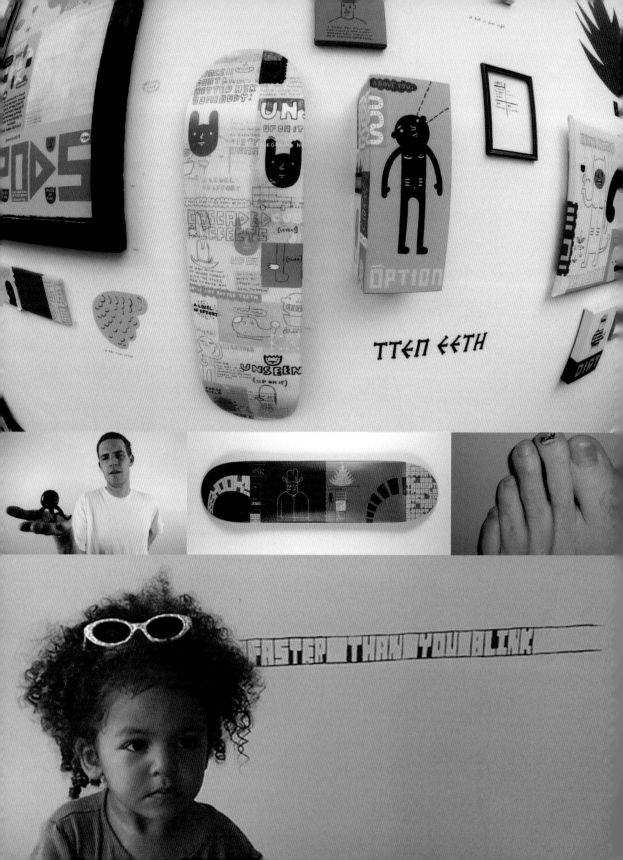

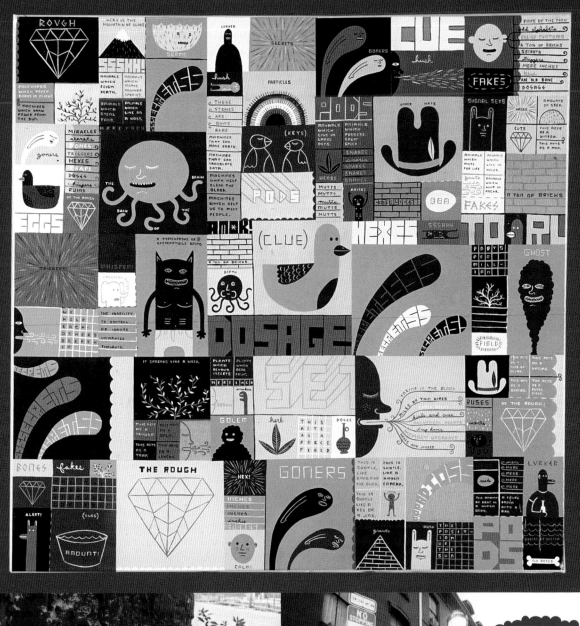

A SENSE OF CALM
FELL OVER THE PACK
AS THE LARGEST
TOOK COMMAND.

WALKS TO THE STORE
OR TO THE DOCTOR,

PLUS THE IMPORTANCE OF SURROUNDING
ONESELF WITH A VARIETY OF SUPPORT
OBJECTS/ SAFE AND INSIDE FOLK'S HOMES

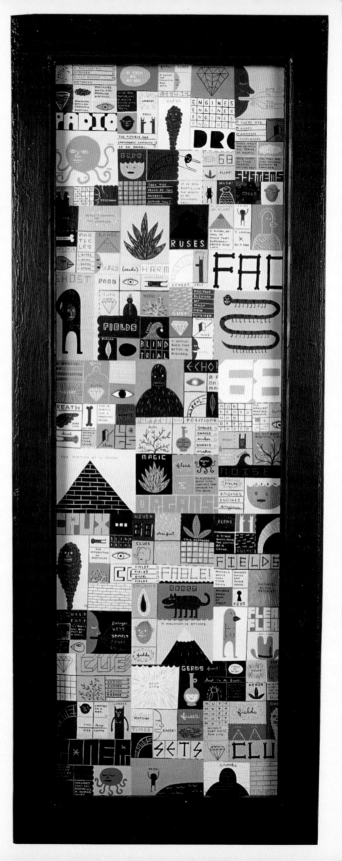

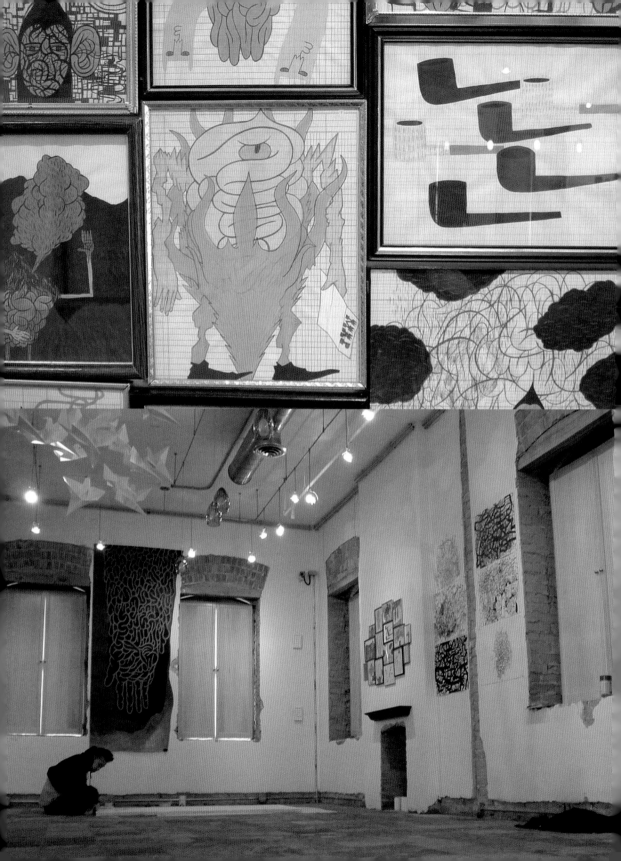

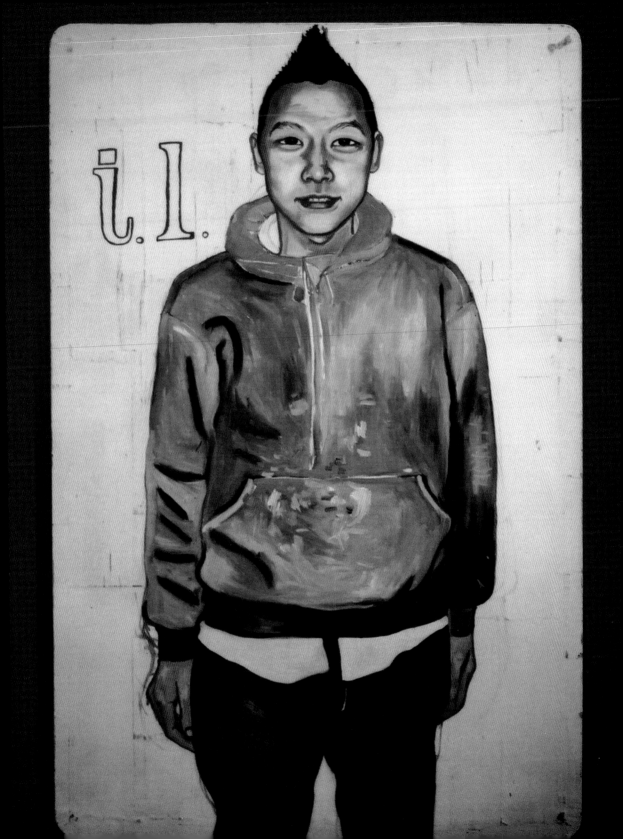

THE STREET LOOKS SAFE

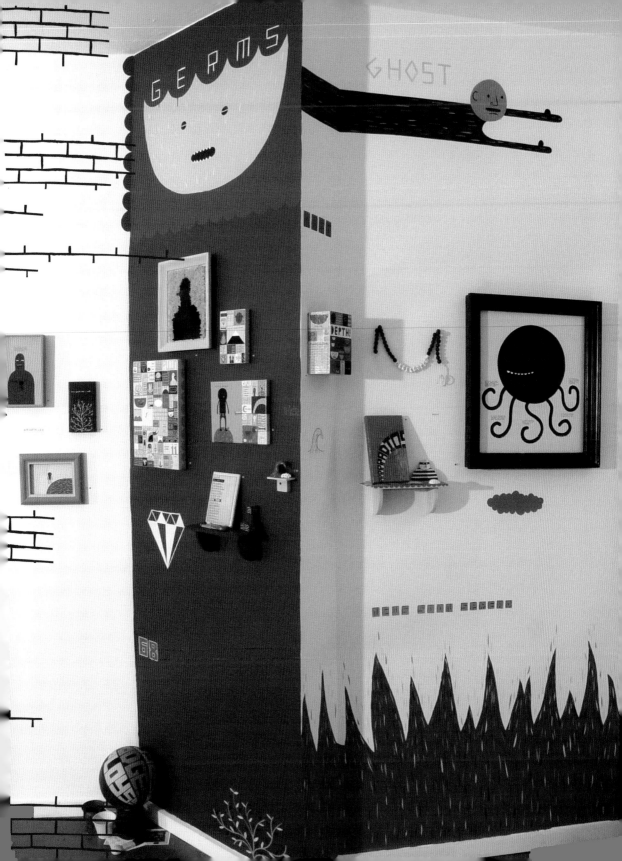

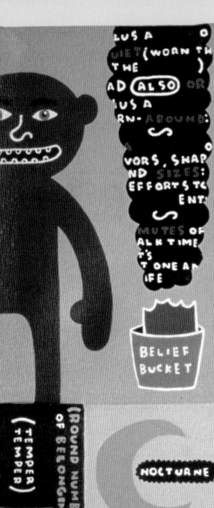

lUS A
QUIET (WORN TH
THE )
AD ALSO OR
lUS A
RN-AROUND:
A
VORS, SHAP
ND SIZES:
EFFORTS TO
ENT:
MUTES OF
ALK TIME
T'S T ONE AN
IFE

BELIEF
BUCKET

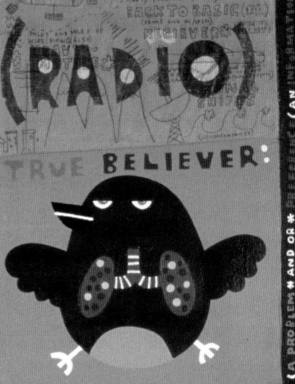

(RADIO)

BACK TO BASIC (OR)
RECIEVER

TRUE BELIEVER:

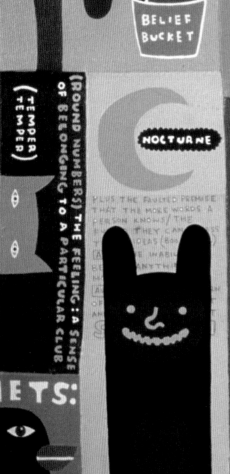

(TEMPER)
(TEMPER)

(ROUND NUMBERS) THE FEELING: A SENSE OF BELONGING TO A PARTICULAR CLUB

NOCTURNE

PLUS THE FAULTED PREMISE
THAT THE MORE WORDS A
PERSON KNOWS/ THE
THEY CAN PRESS
IDEAS (BO
INABILI
ANYTH

JETS:

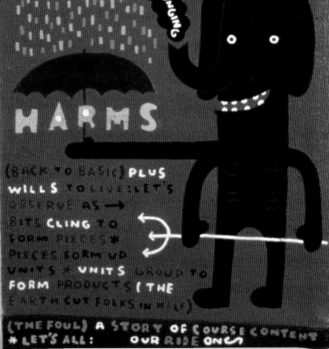

THAT: SENSE OF BELONGING

decievers

HARMS

(BACK TO BASIC) PLUS
WILLS TO LIVE: LET'S
OBSERVE AS →
BITS CLING TO
FORM PIECES *
PIECES FORM UP
UNITS * UNITS GROUP TO
FORM PRODUCTS ( THE
EARTH CUT FOLKS IN HALF)

(THE FOUL) A STORY OF COURSE CONTENT
* LET'S ALL:     OUR RIDE ON

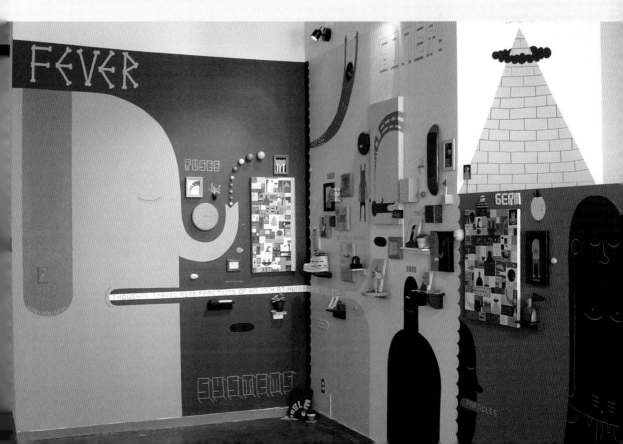

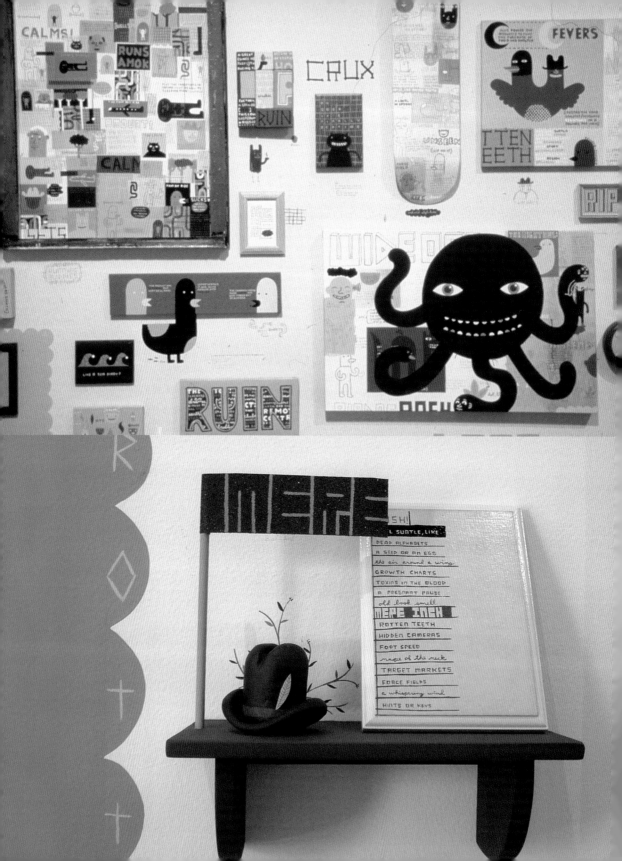

A REMANUFACTURED SYSTEM OF
BELIEFS / A RANGE OF LIFE
IMPROVING PRODUCTS.

---

ATTEMPTS AT CONTACT OVER DISTANCE
WIEGHT LOSS / MEMORY LOSS / FICTION

* IT WILL STAY WITH YOU FOR
EVERY SINGLE SECOND.

FACTORY
SPECS

DEFINED BY WIEGHT AND HORSE POWER
(THE BEEN AROUND)

* POSITIONS HELD UPWARDS OF ONE
WHOLE HOUR.

{the been arounds}

A BETWEENER

(PLUS MILD BELIEF IN GHOST / TELEPATHY.)

THATS A COMMON PROBLEM THAT
HAPPENS ALL OF THE TIME

BUILT LIKE:
HAUNTED CITY BLOCKS

LUMP SUMS

THE UNSEEN

HOW THE UNSPEAKABLE ALL OF
A SUDDEN BECAME SPEAKABLE

# HUSH!

REAL SUBTLE, LIKE

DEAD ALPHABETS

A SEED OR AN EGG

the air around a wing

GROWTH CHARTS

TOXINS IN THE BLOOD

A PREGNANT PAUSE

old book smell

MERE INCH

ROTTEN TEETH

HIDDEN CAMERAS

FOOT SPEED

nape of the neck

TARGET MARKETS

FORCE FIELDS

a whispering wind

HINTS OR KEYS

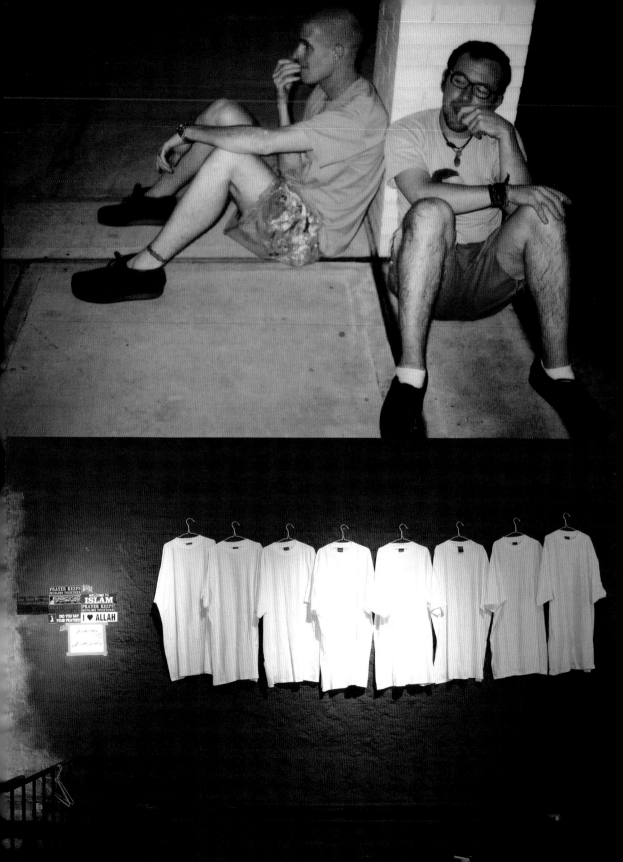

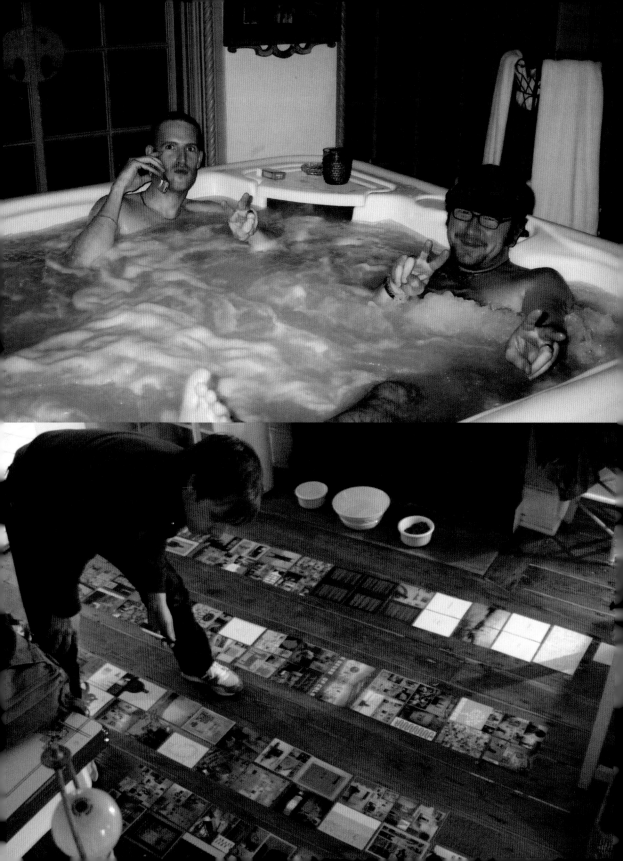

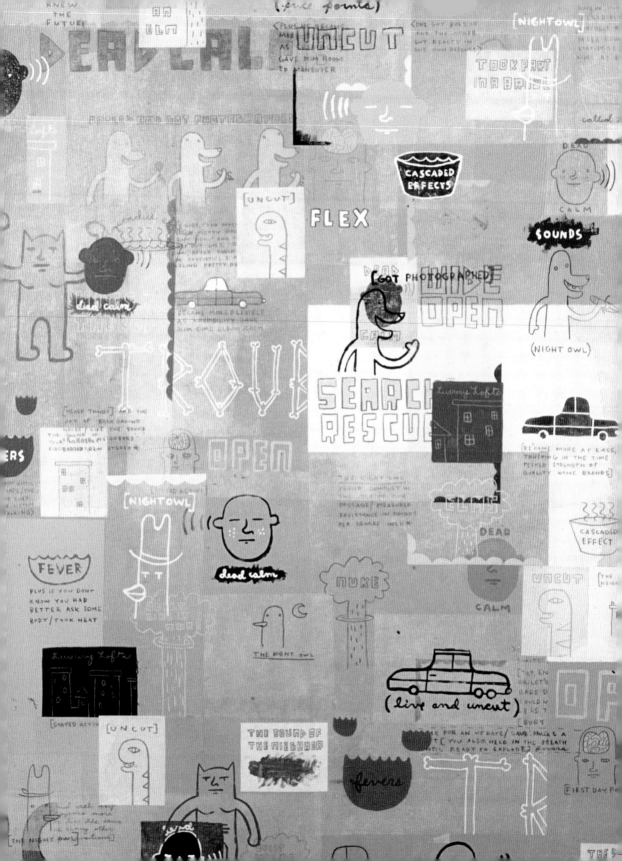

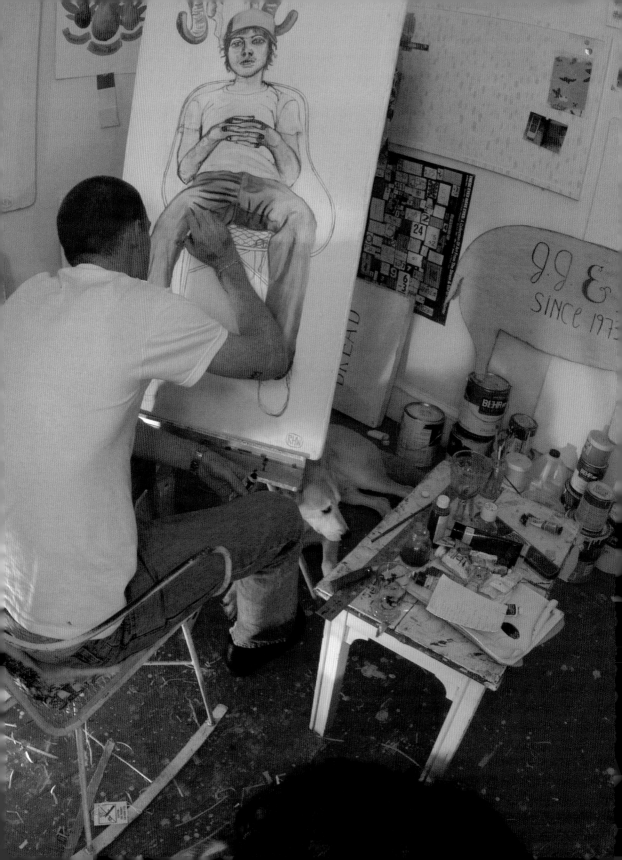

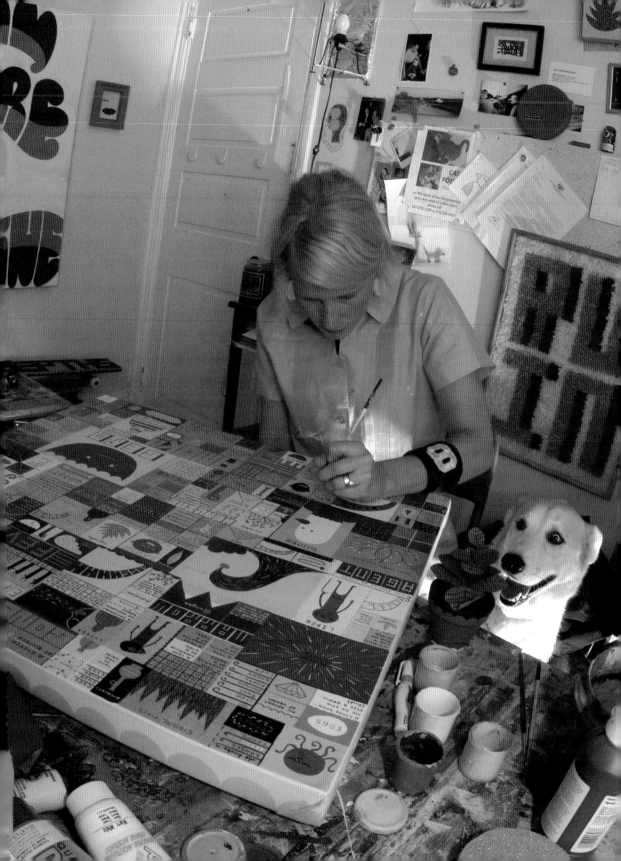

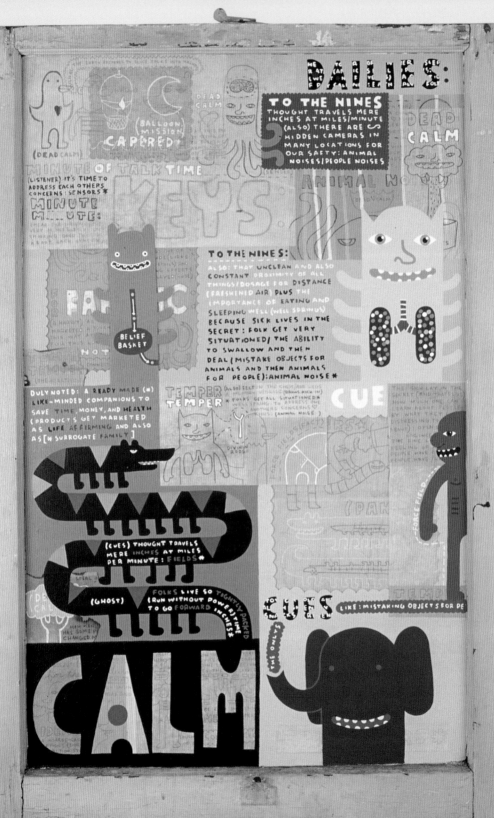

TOP OF HEAD

SENSOR!

MOTOR

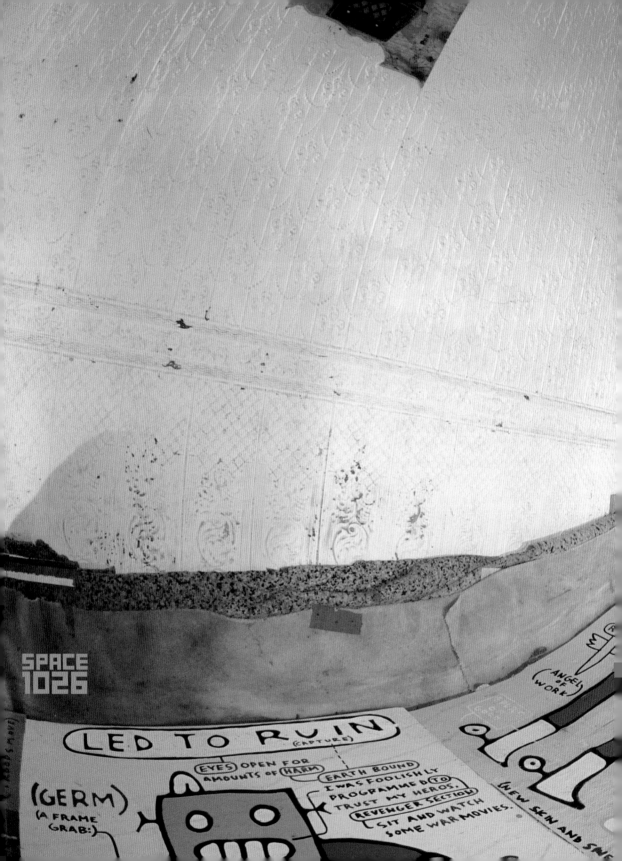

SPACE
1026

LED TO RUIN (CAPTURE)

EYES OPEN FOR
AMOUNTS OF HARM

(GERM)

(A FRAME
GRAB:)

EARTH BOUND
I WAS FOOLISHLY
PROGRAMMED TO
TRUST MY HEROS.
REVENGER SECTION
SIT AND WATCH
SOME WAR MOVIES.

ANGEL
OF
WORK

NEW SKIN AND SN

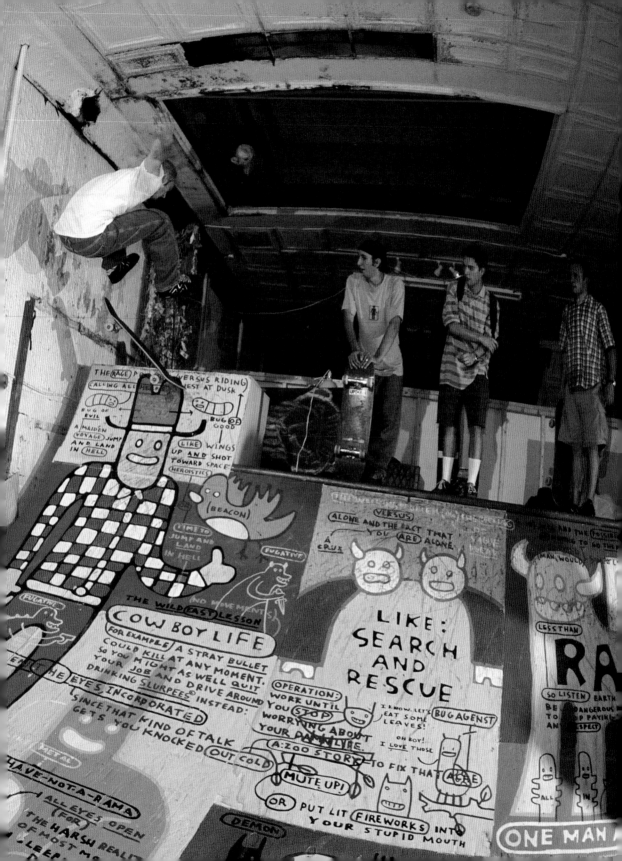

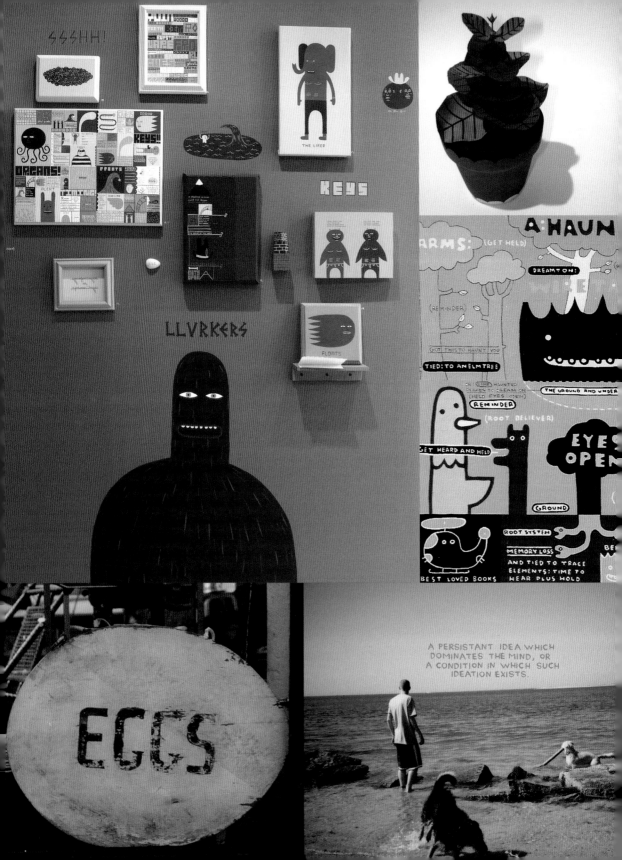

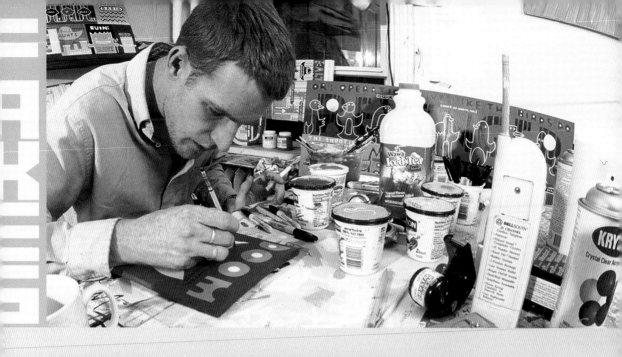

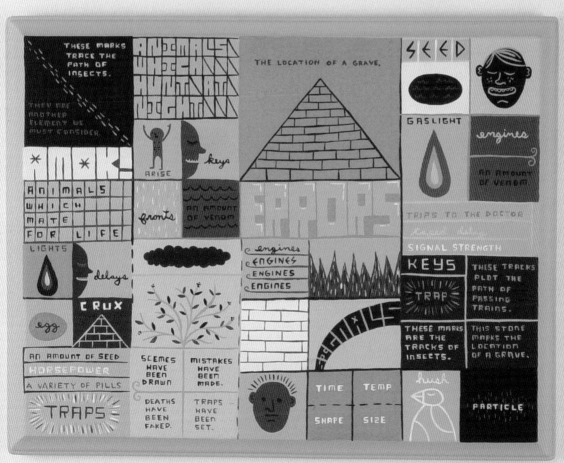

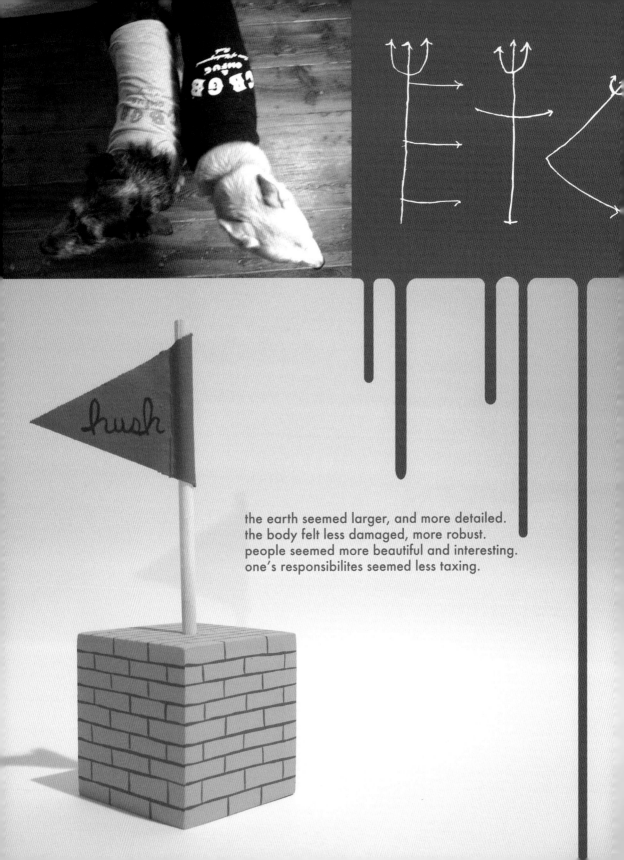

*hush*

the earth seemed larger, and more detailed.
the body felt less damaged, more robust.
people seemed more beautiful and interesting.
one's responsibilites seemed less taxing.

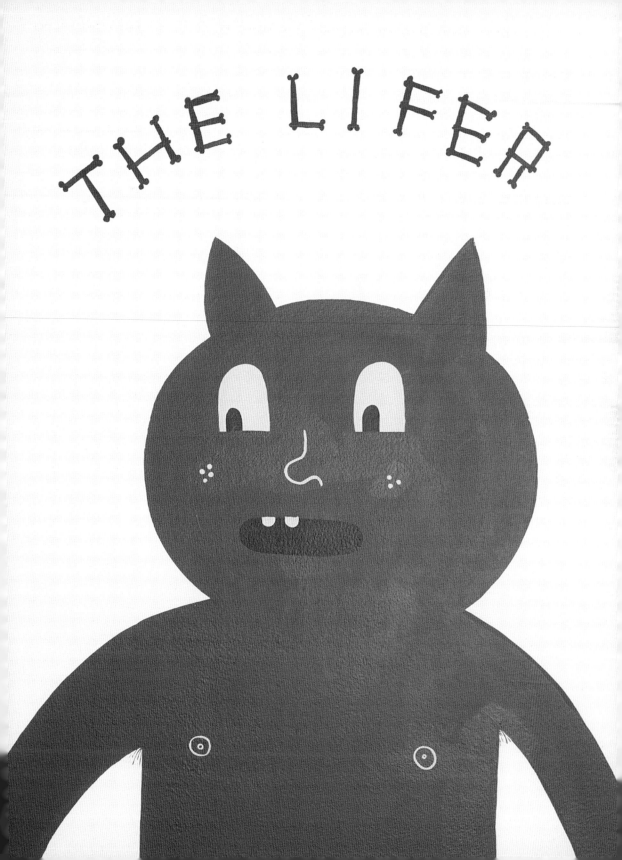

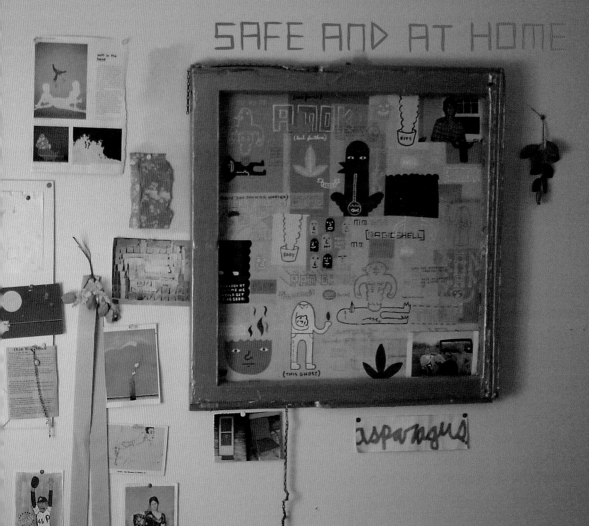

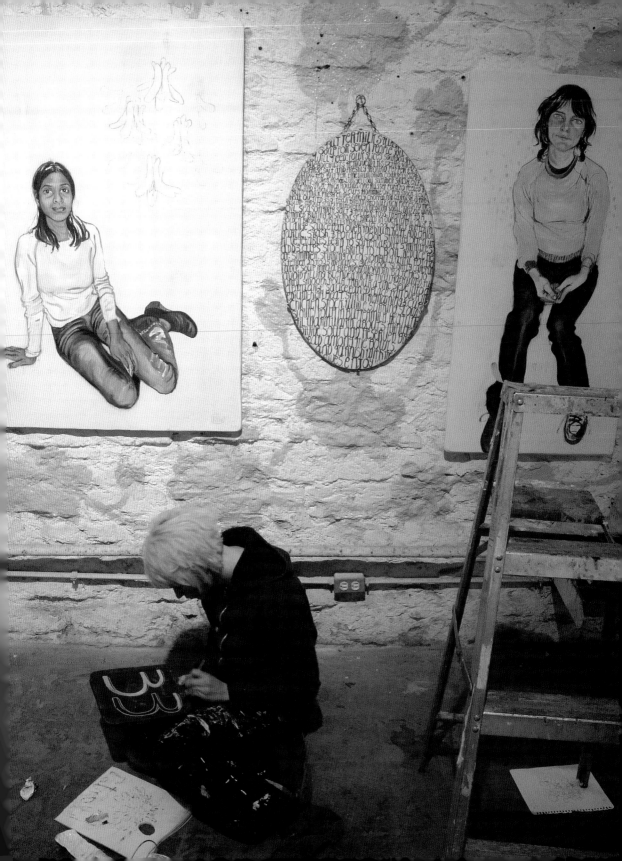

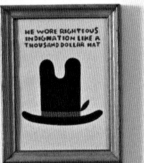

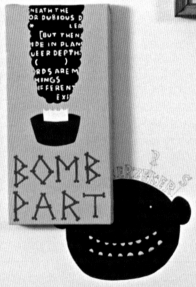

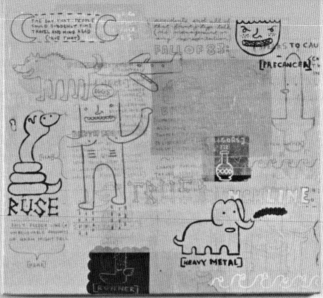

(FOREVER FELT)

RUSE

HEAVY METAL

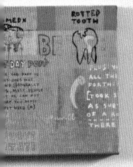

(betweeners)

BACK to B

JAKES

THERE ARE HIDDEN CAMERAS EVERYWHERE

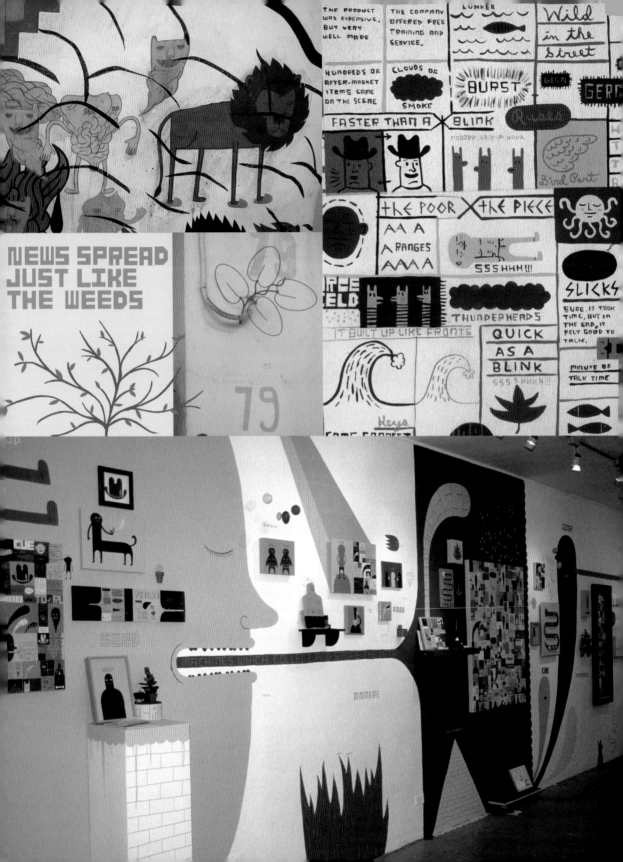

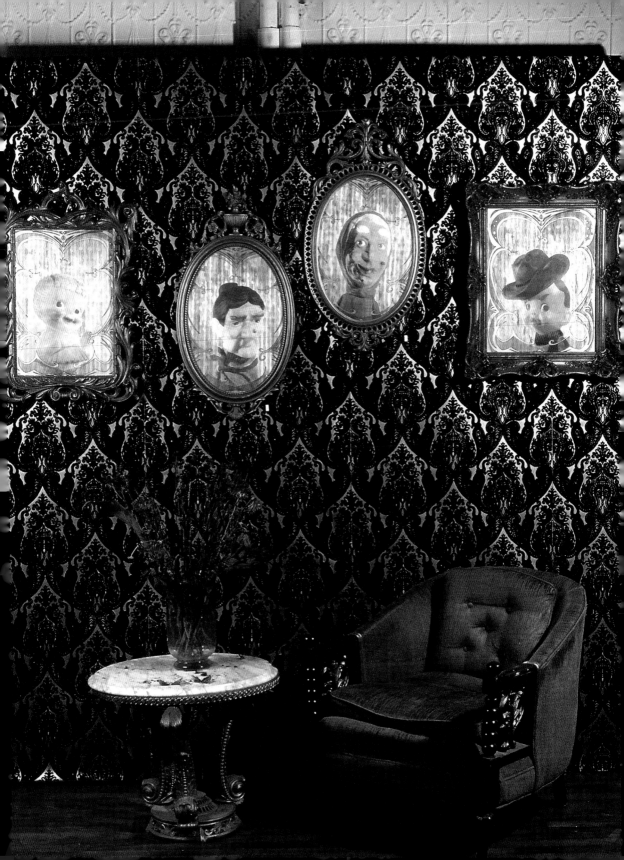

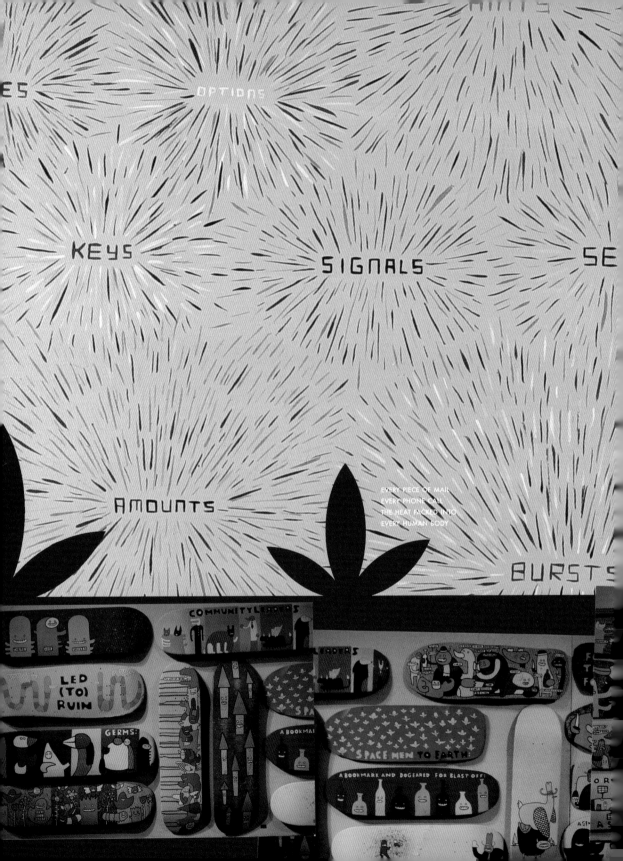

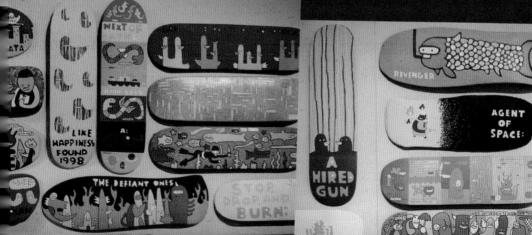

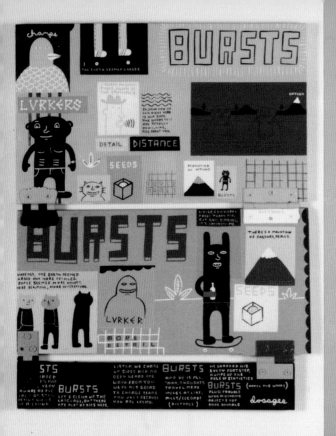

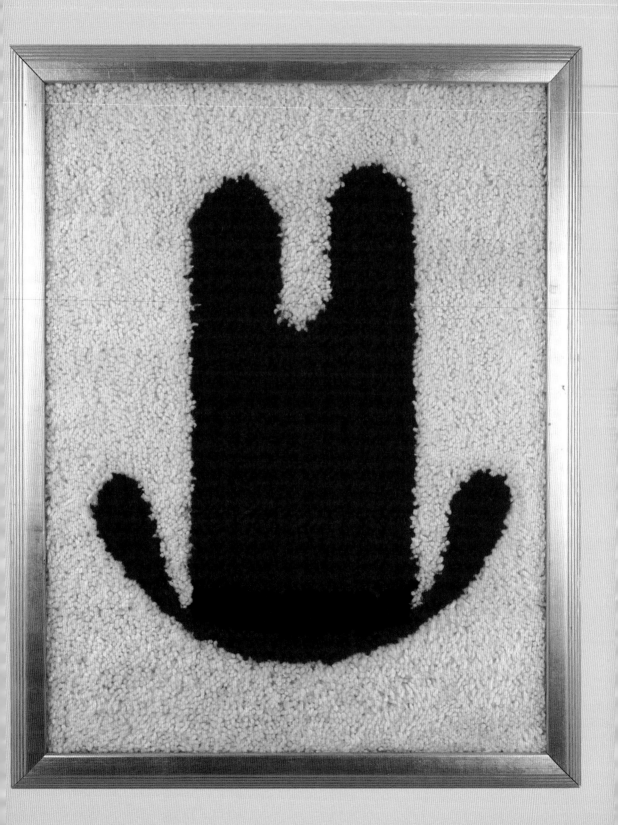

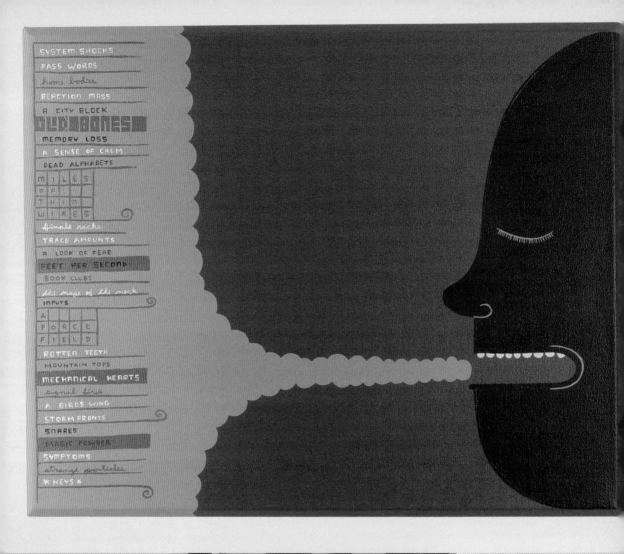
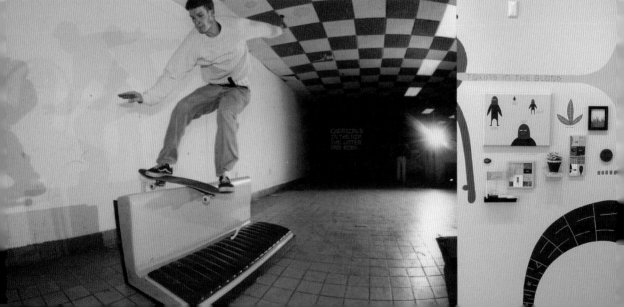

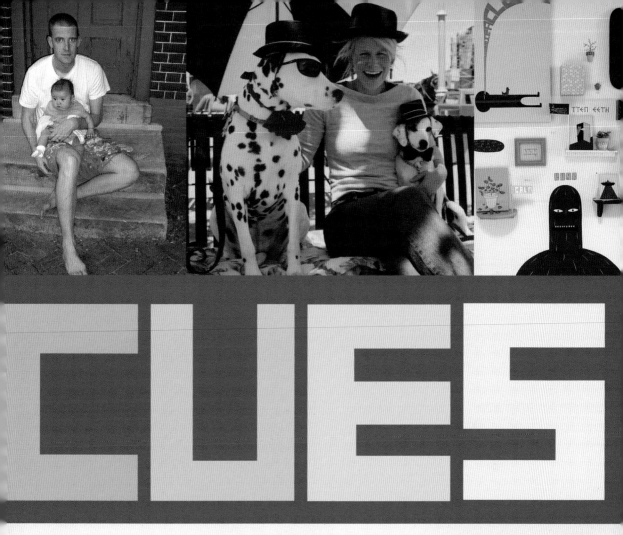

# CUES

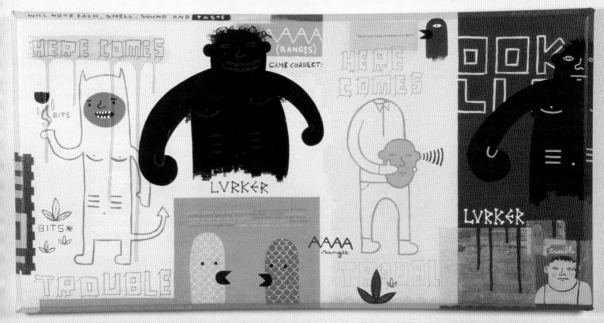

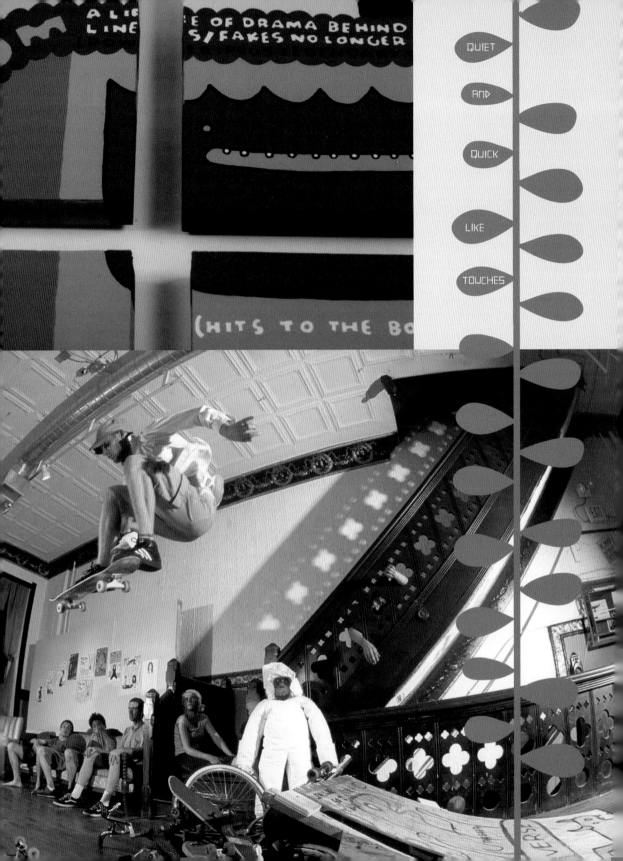

QUIET

AND

QUICK

LIKE

TOUCHES

# ORBITS

INFORMATION IN THE
FORM OF TINY BITS
OF NOISE

SNARES

A LOAD BEARING ANIMAL

fields

THE AREA AROUND
THE EYE OF A BIRD
OR INSECT

HIDDEN
CAMERA

SUPPLIES OF SEED

AN INVISIBLE GUEST

THE NAPE
OF
THE NECK

A NECKLACE OF TEETH

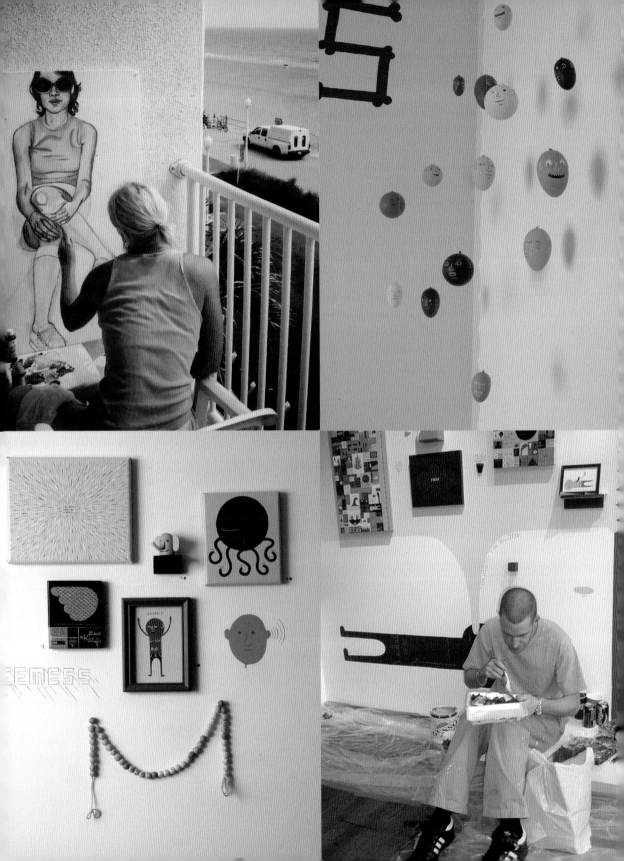

# LLL HOMESWEET

[CALLED FOR: STEPS]

(ALSO WHAT WILL
HAPPEN WHEN
FOLK DISCUSS } HEAD
THIER WANTS
AND ALSO NEEDS)

THE IMPORTANCE
OF ACTING AND
SLEEPING RIGHT
[ BELLY ]

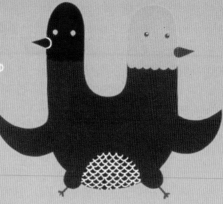

## GUTS

SYSTEM
SHOCKS

HABIT

nevengers

(COUNTING CONTENT) A FULLY
ARTICULATED ACTION FIGURE
CAST IN ONE'S IMAGE / GUTS
(COUNTING CONTEXT) THE BEST
THING ABOUT HAVING LITTLE
OR NO CHOICE IN MATTERS / AN
ESCORT (ARMED) AND BULB
HATCH) DOUBT SHOOK DETAILS

OPERATING SYSTEM

MATCHES

DISPENSER
LUXURY
APTMEN

(HOME SWEET)

## POD'S

PIECES
OF FIRE

THEY HOLD IN ALL
OF THIER BREATH
( HIGH WATTS )

PIECE
OF FIRE

PIECE
OF FIRE

[GOT]

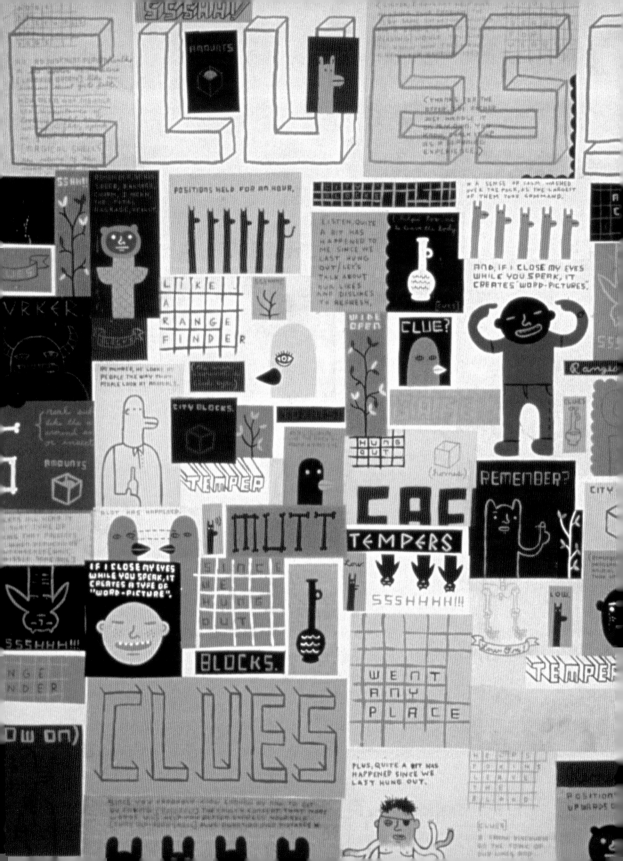

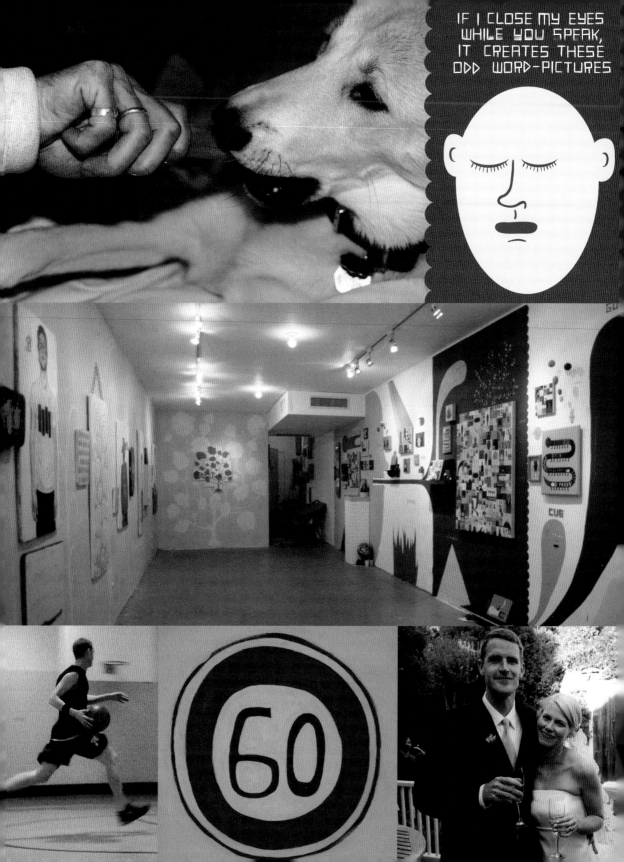

IF I CLOSE MY EYES
WHILE YOU SPEAK,
IT CREATES THESE
ODD WORD-PICTURES

THE BACK
PART OF
A BRAIN

OLD ALPHBETS

SLEEPING
NOT CRYING

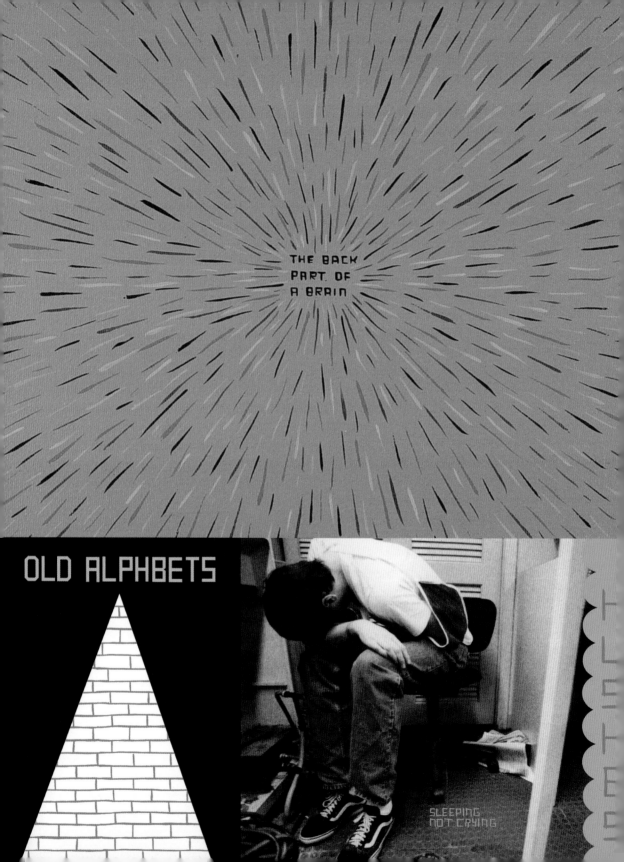

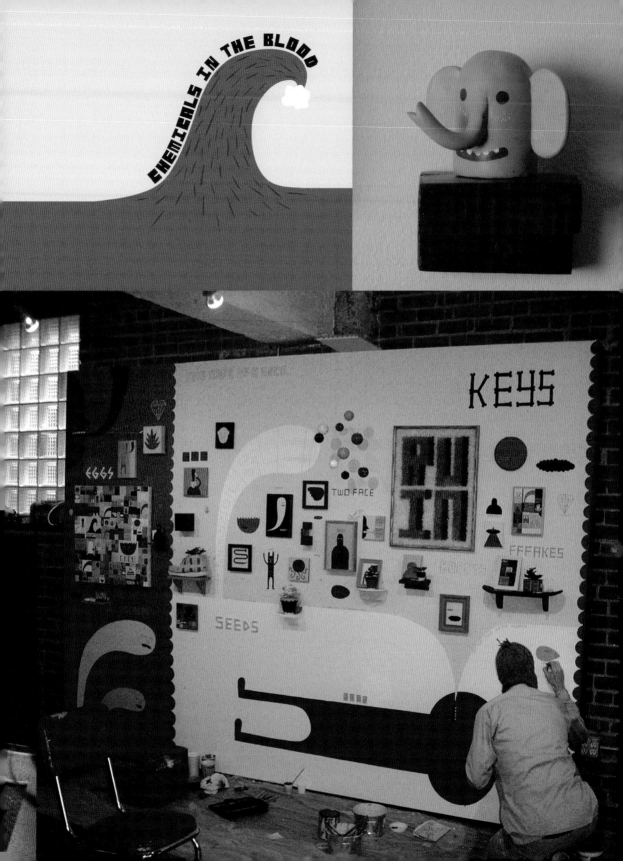

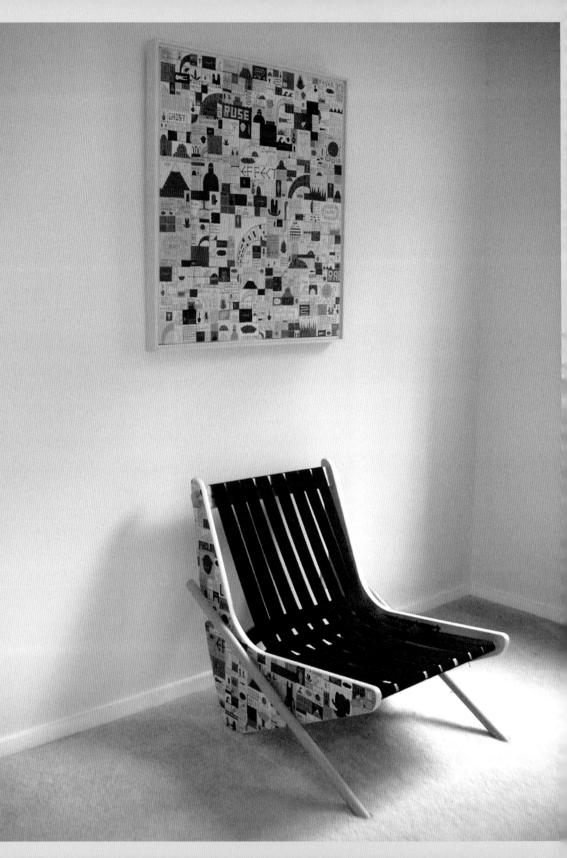

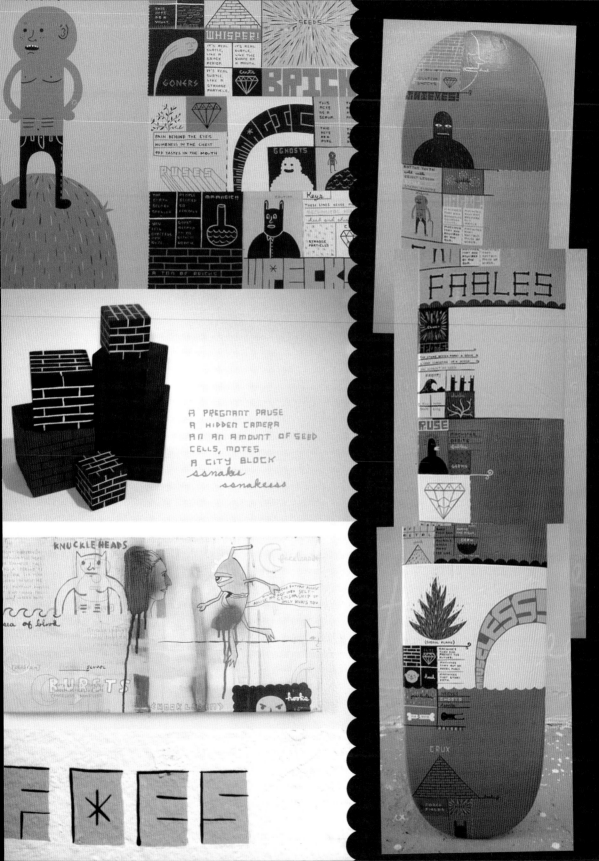

I began to gather materials and work on this book toward the end of the summer of 2004. My wife, Rebecca Westcott, was killed in a car accident on October 12th. I miss her so much that I physically ache. My world revolved around my wife in every way. She guided and fueled my art, and my life.

The last few months have challenged me to stay positive. Becky taught me so much about facing each day with optimism and excitement. She loved her life, the woman she had become, and the people that surrounded her. Of all the emotions that have raced through my mind of late, the dominant one is gratitude. I am so lucky to have had eight years with such a woman. I am so thankful for all she taught me about life: how precious it is, and what is truly important.

The best way for me to honor Becky is to try to be more like her, and to continue to do the things that made her happy and proud, through my art and through my actions. I want to continue to be the person that Becky helped me to become. I want to be a constant reminder of her legacy.

This book is a window into every facet of my life. There isn't a single element of my being that she did not affect or inform. Anything that I have accomplished in my life is simply a testament to what can be done if you are willing to dedicate your entire life to another person.

True love is out there. It can change you forever. It can help make the world a more beautiful place.

I love you, Becky.

12/13/04

# ACKNOWLEDGM.
# ACKNOWLEDGMENTS

MOST IMPORTANTLY, I'VE LIKE TO THANK ADAM WALLACAVAGE. 99% OF THE PHOTOGRAPHS IN THIS BOOK CAME FROM HIS CAMERA. ADAM HAS BEEN A GREAT FRIEND AND A HUGE INFLUENCE FOR OVER FIFTEEN YEARS. NOT EVERYONE IS AS LUCKY AS I AM TO HAVE SUCH A PERSON IN THIER LIFE, AN I CANT THANK HIM ENOUGH FOR BOTH HIS SUPPORT AND HIS WILLINGNESS TO DOCUMENT MY WORLD FOR ME. I LOVE YOU, ADAM.

and all of these people helped fuel this book:

MY MOTHERS (PEG AND NADINE) MY FATHERS (DON AND BILL) MY SISTERS (JEN, SHEILA, WENDY, AND JAIME) AND BROTHERS (MATT, JOE, DENNIS) MY GRANDMA CICELY, TIM AND SUE + MY WHOLE EXTENDED FAMILY. BRIAN LYNCH, BEN WOODWARD (AND CHI + ATARI) SHELLEY SPECTOR + YVONNE, NOLA, AND MARGO. SPACE 1026ERS. MISS MELISSA PARKER AND MISS MARY CHEN HELPED ME GET BACK UP. MAX, MORGAN, AND NED LAWRENCE. THE AFBL ALL-STARS + JOHN FREE BORN. DAN MURPHY. SCIENCE FICTION, ISAAC LIN, SWEATHEART, ALL KINDS OF ANIMALS. ALEX BAKER, ED AND DEANNA TEMPLETON, ANDREW KUO, CHRIS JOHANSON + JO JACKSON, ISIAH ZAGAR, LORI D., ANDY WRIGHT, KARL PAUL. MATT LIENES, STEVE POWERS, CLARE (AND BARRY, FOR SHOWING THINGS GET A LITTLE EASIER) LIGHTHOUSES, MICAELA, LISA, AND WHIT. THE DUDE RANCH. CYNTHIA CONNOLLY, HOUSEPLANTS, DICK AND DIANE BURNS, ROBIN + BRAD. UNDER THE EIGHTBALL, PABLO'S TWO HUNDRED DOLLARS, VIN, STEVE, AND TOM. THE ROOM AT THE PMA WITH ALL THE TWOMBLY'S IN IT. RVCA, SPORTSCENTER, MARSEA AND NEW IMAGE. SHEP AND AMANDA AND GEORGE. THE SIXERS. NICK HALKIAS BRANDT AND KATHY, JONATHAN LEVINE, JESSICA, NOCTURNAL, BOOKS ABOUT GHOSTS, CROWNFARMER, TOY MACHINE, 686, MORRIS ANIMAL SHELTER. ROGER AND TONY, THE CITY OF PHILADELPHIA. ANY GALLERY WHICH OFFERED ME A HAMMER, A NAIL, A BLANK WALL, KOREY CAPOZZA, BRENDAN + ASHLEY, ZINES, 4-TRACKS, MIXTAPES, ALL AGES SHOWS, AND SKATEBOARDING, AND OF COURSE, MY BECKY, MY BECKY, MY SWEET, SWEET, BECKY.

JIM HOUSER, FEB 2005

SAYING SO.

INALE RACKS / THE ABILITY TO
O HOURS, NO, DAYS WITHOUT
SPEAKING.

(NOCTURNES)

the wide opens

THAT UNCLEAN PROXIMITY OF ALL
THINGS [AN UP AND COMER]

(since) you probably know
enough by now to get on
by faking [RUSE FELT] that
old book smell / that faultier
concept that more words
will help you express yourself
clearly [LIMITER] Let's focus in
as almost pushes in over edges
[CUES/ HOTZONES/ GRASPS]

SPACE AND WARMTH AND OBJECTS.

BITS CLING TO FORM PIECES TO
FORM UNITS FORM PRODUCERS.

TEMPER | ROUND #'S THE SENSE
TEMPER | OF BELONGING TO A GROUP.

FOR THE FOWL!

ILL USE YOUR
REAL NAME
AND NOT YOUR
CODE NAME

KEYS
temperature / scents
MADE OF METAL
OFF THE HEAD

CLOSEST OF
SMOKE!

LIKE HOW THOUGHTS TRAVELS
MERE INCHES AT FEET PER SECOND.

EXPLAN, THINKING ON ONES FEET,

HARM

AN INTEREST
TO NOTE
THAT
K

(HIDES IN PLAIN SIGHT)

HITS TO THE BODY

A MOUNTAIN
OF FACTORS

ANIMALS WHICH
ANIMALS WHICH
ANIMALS WHICH
ANIMALS WHICH
ANIMALS WHICH L

PARTIC

KEYS

LOSS OF SEN
RINGING EARS
SKIN ERUPT

I SHOULD REALLY LOOK FOR A JOB
THAT IS CLOSER TO MY HOME

THIS TRAFFIC IS MADDENING

[SHORT STORIES]

A) A YOUNG MAN SEARCHES SEVERAL
STORES FOR A GOOD DEAL ON BATTERIES

B) ALONG A WATERWAY OF SOME
SORT A MAN FIRES A GUN AT
SOME BIRDS

C) TWO STUDENT ATHLETES MAKE
BETS ON SHOTS AT PRACTICE

D) ALTHOUGH HER NAME WAS
MILLIE, HER MICHIGAN VANITY
PLATE READ... "BILLIE"

E) AN OFF DUTY COP STRUGGLES
WITH THE LID OF A MAYO JAR.

F) AND THERE IT WAS, STUFFED
ON THE MANTLE, AN ALASKA MINK

G) MAN SEARCHES HIS GARAGE
FOR A PARTICULAR PIECE OF
PIPE.

F) A TEEN CONVERTS A BOMB
SHELTER TO A MAKE SHIFT
APARTMENT

LETS WATCH CLOSE AS, PEERS
REMARK ON THE NEW FOUND
CLOSENESS THROUGH SOME
GOOD NATURED RIBBING.

HOSTILE

MARKS THE FIRST TIME YOU
FELT REAL CONCERN FOR A
TOTAL STRANGER.

A HUMAN SHIELD

BACK GROUND

OUND SYSTEMS / RECORD SETTING HEA
TYPES OF WEATHER / SMELL OF THINGS

N NUTES OF TALK TIME / THAT THINGE
TYPES OF AIR FLOATS UP THERE

fields

- mmmm, fields

LOGS

ILL GOTTEN AND ROCKED
WITH AUTHORITY. LISTEN,
WE MAY BE ABLE TO FIND
A SAFE PLACE / WE WILL TRAVEL
IN SILENCE BY MOONLIGHT.

ALSO, SADLY THIS
DOES NOT LAST
AND GENERALLY MOST
FOLKS WILL NOT OR
CAN NOT GIVE YOU
WHAT YOU MOST NEED

929

TAKE ( TAY WITH ME
PART ( FOR A LITTLE WHILE )

A PERSISTANT IDEA WHICH
DOMINATES THE MIND /
A CONDITION IN WHICH
SUCH IDEATION EXISTS

THOUGHTS TRAVEL MERE
FRACTIONS OF AN INCH
AT FEET PER SECOND

BELIEF IN GHOSTS
MY BLOCKS

SUBTLE, LIKE HOW IT
UNSPEAKABLE CAN BECOME SPEAKABLE

BLOOMS